Maryland's APPALACHIAN HIGHLANDS

Maryland's APPALACHIAN HIGHLANDS

MASSACRES, MOONSHINE & MOUNTAINEERING

Tim Rowland

Charleston · London

THE
History
PRESS

Published by The History Press
Charleston, SC 29403
www.historypress.net

Bottom cover image courtesy of the National Park Service.

First published 2009

Manufactured in the United States

ISBN 978.1.59629.668.8

Library of Congress Cataloging-in-Publication Data

Rowland, Tim, 1960-
Maryland's Appalachian highlands : massacres, moonshine, and mountaineering / Tim
Rowland.
p. cm.
ISBN 978-1-59629-668-8
1. Maryland--History--Anecdotes. 2. Appalachian Region--History--Anecdotes.
3. Uplands--Maryland--History--Anecdotes. 4. Mountain life--Maryland--History--
Anecdotes. I. Title.
F187.A16R69 2009
975.2'9--dc22
2009013739

CONTENTS

Acknowledgements 7

Introduction 9

Chapter 1 The Mountains' Rocky Beginning 15

Chapter 2 Native Americans Exit the Hills 23

Chapter 3 Settlers Face an Uphill Battle 31

Chapter 4 Maryland's Daniel Boone 41

Chapter 5 A Road Pierces the Wilderness 49

Chapter 6 The Mountains Get to Work 59

Chapter 7 War at the Summit 71

Chapter 8 A Tale of Two Monuments 81

Chapter 9 The Ghosts of the Gap 87

Chapter 10 The Industrial Revolution Takes a Break 95

Chapter 11 The Army Channels Its Inner Intelligence 103

Chapter 12 What Prohibition? 109

Chapter 13 The Mountains at Play 117

About the Author 127

ACKNOWLEDGEMENTS

One of the pleasures of writing history is that fellow history fans are almost universally willing and enthusiastic about sharing what they know—from scholars to archivists to historical society volunteers.

A number deserve special mention for the help they provided to me. John Frye, Elizabeth Howe and Jill Craig of the Western Maryland Room in the Washington County Free Library provided information, pulled countless files and coordinated photos. Special mention should also be made of www.whilbr.org, the splendid site for the Western Maryland Historical Library. It's an invaluable resource for anyone interested in Western Maryland history.

Thanks also to those who gave so generously of their knowledge through personal interviews and are quoted in this book. Also, thanks to the many authors I quote from in this work, whom I know only through their words but am no less grateful to.

Assembling the photos was made much easier through the help of Doug Bast of Boonsboro; Frank and Suanne Woodring of the *Maryland Cracker Barrel* magazine; and Eleanor Callis and Martha DeBerry of the Garrett County Historical Society.

In an interesting twist of fate, Cassandra Pritts, archivist for the Allegany County Historical Society, helped me sort photos in the kitchen of the Brooke Whiting House of Art, the same kitchen where Albert Einstein sat and chatted with Dr. Whiting on his way to Deep Creek Lake.

It's also overwhelming work when a writer is "plowing new ground" on topics with which he is not terribly familiar or where an abundance of information would deny simplicity. Tom Clemens sorted out the Civil War for me, Lloyd Waters explained the finer points of moonshining and John Means was kind enough to pretend not to notice my blank stare when he was talking about Pangaea.

ACKNOWLEDGEMENTS

Of course any mistakes in this work are mine alone, although I have strived to make these mistakes original and interesting.

Finally, a professional and understanding editor is key to any book, and I'd like to thank Hannah Cassilly of The History Press for her guidance and for being there with reassurance for every turn and road bump in the process. An understanding wife helps, too, so thanks and love to Beth for working alongside me and providing a vital search and recovery process for the estimated four thousand times that I lost my memory stick.

INTRODUCTION

No one will confuse the mountains of Western Maryland with the Himalayas, even though twice in their geological lifetime they have soared to similar heights. There are no year-round snowcapped peaks, even though freak summer snowstorms are legend. No celebrated climbers set out to conquer their heights, even though their beauty has been compared, perhaps liberally, to the Sierra Nevadas.

The highest point in Maryland is Hoye Crest up on Backbone Mountain in Garrett County, although you have to drive through West Virginia to get there. At 3,360 feet above sea level, it cannot be considered a towering massif. It's half the height, give or take, of the East's more celebrated ranges—the Smokies of North Carolina, the Adirondacks of New York and the White Mountains of New Hampshire.

Yet what Maryland's mountains may lack in vertical drama, they make up for in history. That's because the climate and topography are not so severe that they discourage human interaction. They have that "lived-in" look. Towns cling to the hillsides, and farm fields frequently go right up to, and sometimes over, the ridgelines. They are manageable enough that, for a time, engineers believed that they could build a canal through their heights to connect with the Ohio River to the west.

The mountains have a rich history of work and play. Railroads crisscrossed the region, hauling out timber and minerals and hauling in vacationers who in summer took advantage of the cool air and ample waterways.

Indeed, the relatively low mountains made transportation easier and provided a natural gateway to the West. This is not to say that they were easy to cross, but they were *possible* to cross. The nation's first federally funded road, combined with roads financed by banks, was the main link to the new territories that came with the Louisiana Purchase. The C&O Canal did

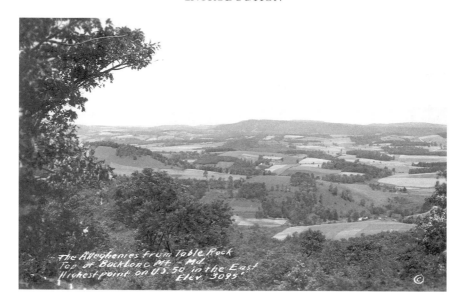

The Alleghenies from Table Rock
Top of Backbone Mt. - Md.
Highest point on U.S. 50 in the East
Elev. 3095'

The rolling hills of the Allegheny Plateau, as seen from Backbone Mountain. *Courtesy Garrett County Historical Society.*

make it as far as Cumberland before the railroads essentially put both it and the National Pike out of business.

But this transportation was key to the mountains' development, and with the people came a lively history that more inaccessible ranges cannot touch.

The White Mountains are known for its "Presidential Range," but this is more for the names of the peaks—Washington, Jefferson, Madison and so on—than it is in actuality, where the Maryland mountains would have the better claim.

George Washington was an early champion of the region. Andrew Jackson chatted up the townsfolk on the National Road—he was friendly "but not particularly good looking," confessed a Hagerstown woman. Presidents Cleveland, Wilson and Eisenhower played the links atop South Mountain near the popular PenMar Park. Taft gave a speech at Mount Lake Park, a visit remembered less for his words than for his considerable bulk, which required his hosts to modify a car by removing a seat so they could give him a tour. Warren Harding camped with Henry Ford and Thomas Edison outside Hancock. No fewer than seven presidents reposed at the stone Woodmont Lodge, an exclusive spot for the likes of Gene Tunney and Babe Ruth. Finally, of course, Camp David, the former "Shangri La," has become a staple for presidential business and pleasure. In fact, it's harder to find a president who has not set foot in the mountains of Maryland.

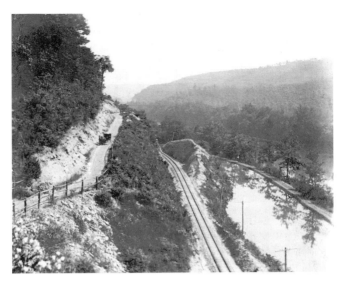

A wagon road runs alongside the railroad, C&O Canal and Potomac River in western Washington County. The wagon descending the hill is the public library bookmobile, the first mobile library in the nation. *Courtesy Washington County Free Library.*

Fittingly, the first Washington monument to be completed was located on a Maryland mountaintop in Washington County. The mountains have known conflict. Indian raids terrorized early settlers during the French and Indian War. As protection, a sizable stone fort was built along the Potomac, but it was abandoned soon after and sold to a free black man, who planted fruit trees within its walls and sold vegetables to both sides during the Civil War. A major battle of the Civil War was fought on a mountaintop. Nuclear bombs have fallen on the Maryland mountains. Honest.

Hundreds of fifty-acre lots were drawn up in Western Maryland and given to veterans of the Revolutionary War, most of which were summarily sold to land speculators for a few dollars or a jug of whiskey.

These lands soon became enormously valuable, supplying a young nation built from Maryland's iron, coal, timber and brick. And the hardscrabble towns that popped up to milk the mountains of their resources produced more than coal. Lefty Grove, regarded by some as baseball's greatest left-handed pitcher, was born in Lonaconing. Frostburg produced Pirates first baseman Bob Robertson, and Cardinal (Catholic, not St. Louis) Edward Mooney was born in a company ironworks row house in Mount Savage. Mooney was a supporter of labor—which was natural, considering his roots—and a fan of the links. He once remarked that if your score is over one hundred you are neglecting your golf; if your score is under ninety, you are neglecting your parish. This, the people in the mountains would tell you, is the way to play golf and the way to live.

INTRODUCTION

The mountains have seen their share of grand plans that never got off the ground—the canal to the west; a palatial resort on the order of White Sulphur Springs; and a massive museum complex dedicated to journalists and the ideal of a free press. The mountains have seen their share of grand plans that were put into place—an incredible seventeen-mile rail grade from the Potomac River to the top of the Allegheny Plateau; elegant resorts; and a military base to support a control center carved out of a mountain to be used in the event of nuclear war.

The mountains have been remarkably adaptive. When the minerals and the Industrial Revolution played out, recreation picked up the slack. The canal towpath and the railroad beds became bike paths. Where mining trams once negotiated the slopes, skiers now glide. And mountains that were once good for coal mines below are now good for wind farms above.

Mountain traditions have been lasting. People still talk of ghosts stomping around in the attics of early homes, and moonshiners are still alive and kicking if you know where to look and agree to keep your mouth shut. Many people still poke about in the forest duff, looking for ginseng or the exquisitely flavorful wild mushroom known as the morel.

Much of the history is still locked in the architecture of the main streets of cities like Frostburg, Cumberland and Hagerstown. These streets may not bustle like they did back in the day, but their dignified pasts are still easy to imagine. Some of the smaller towns have become borderline trendy, while others have devolved into ghost towns—an industrial version of the Wild West, the lifeblood of commerce long since gone, but the brick and gray boarded storefronts hanging on like skeletons refusing to crumble under their own weight. Some of these federal-period communities strive for rebirth, counting on tourists and new residents in search of a slower pace to fuel their sprout-intensive sandwich shops, cafés and art galleries. Others like the way they are just fine, thank you very much, and prefer quiet, residential communities not unlike what they were a century ago. For the most part, traditional culture has gone toe-to-toe with modernization and won at least a draw. You are far less likely to find a Starbucks than a tiny grocery selling bait—in the cooler right next to the milk, as a general thing.

But the main glory of the mountains is in the mountains themselves, where brooks gurgle and a cool breeze always seems to blow. "Although these heights of which I speak are not of Alpine or of Altaic grandeur, and the sparkling variety that water gives to the landscape is wanting, yet the encompassing width of view that the summit in is, indeed, most beautiful to behold," wrote Madeleine Vinton Dahlgren, a nineteenth-century owner of a stone inn nestled in a notch of South Mountain. Driving west from

the flat Tidewater on Interstate 70, Braddock Mountain appears as the first major ridge, followed by a wide, rolling valley, followed by the higher South Mountain, another fertile plain of corn and cows, and then Sideling Hill. From there, on what is now Interstate 68, the valleys become narrower and the mountains become higher and choppier. Much of the Old National Pike, or a facsimile thereof, is still in place, and a driver with time can hop off the interstate and retrace "Scenic 40," which dips, turns and rolls like a rowboat on the high seas as it stubbornly beats a path through the mountains.

West of Cumberland is an ear-popping climb up the mighty Allegheny Front, which levels out, sort of, to the Allegheny Plateau, a complex conglomeration of high ridges and lesser foothills. This was once the stomping grounds of hunters, farmers, boaters and wealthy residents from the city in search of relaxation. It is much the same today. Deep Creek Lake, built for electricity in the days when any unharnessed flow of water was viewed as a waste, remains a popular destination for residents from the East seeking the classic mountain-lake setting.

The mountains made early life difficult, to be sure, but they offered their rewards in return. Their iron laid the groundwork for the nation's rapidly growing rail system, their clay built the New York City subway and their coalfields supplied U.S. Navy ships during the Spanish-American War. Pure

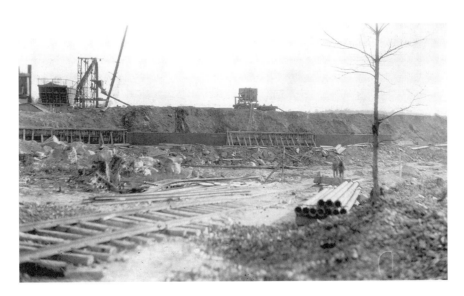

Construction of the Deep Creek Lake dam, which began generating power in 1925. The specially built tracks in the foreground ran twelve miles from the B&O Railroad in Oakland to the project site for transport of heavy materials. *Courtesy Garrett County Historical Society.*

spring water flowing from the mountains has been bottled and shipped around the world.

This history leaves the valleys for the most part and visits the hills, mountain summits and flanks, where people worked and played, built their culture and made their mark on the state and the nation. It also tells how the mountains influenced human behavior, from battles to the flow of settlers heading west. It is by no means all-inclusive but strives to hit the high points, so to speak, of the significant and quaint activities that give the Maryland mountains a special place in American history.

Chapter 1

THE MOUNTAINS ROCKY BEGINNING

Meandering its way through a valley flanked by Braddock and South Mountains, Route 17 leaves the village of Middletown and, heading south, quickly dips down and crosses Catoctin Creek. Here is a rare chance to see an exposed outcropping of the oldest rocks in Maryland, which are thought to be 1.1 billion years of age. "It's not anything dramatic," says John Means, an author and former geology professor. What it represents, however, is the basic building blocks of the mountains in Western Maryland. They are the "basement rocks" of the former North American continent and were formed when lava bubbled up thousands of feet.

A lot of the Maryland mountains' formative, teenage years occurred well in advance of Pangaea, when all of the continents hung together like a bunch of grapes in one big supercontinent some 250 million years ago between the Paleozoic and Mesozoic Eras. So we're talking way back there.

For our purposes, the Western Maryland mountains consist of three provinces that are called, east to west, the Blue Ridge, the Ridge and Valley and the Allegheny Plateau. Catoctin and South Mountains are in the Blue Ridge. Although it may not have seemed like it to early settlers, they are rather low and gentle, like elongated beer bellies running north and south. To the west of Clear Spring, the mountains grow taller but still maintain some degree of ordered ridgelines, interspaced with increasingly narrow valleys, hence the Ridge and Valley designation. After that, the mountains stop playing nice.

Leaving La Vale and heading west, steep roads assault Dans Mountain, which represents Maryland's entry in the Allegheny Front, the headwall of the Appalachians, which stretches from Tennessee to New York.

If "Ridge and Valley" is an accurate portrayal, "Allegheny Plateau" is not, at least not if one connotes plateau with being relatively level. Level the

Allegheny Plateau is not. Here the mountains have names like Backbone, Big Savage and Warrior. Savage likely received its name from Indian atrocities, but some say that it was named after eighteenth-century surveyor John Savage. Either way, the weather can be rough. Lore has it that Savage and his crew were stranded in a blizzard, and being the charitable sort, Savage told his men that they could eat him if worse came to worst. They were rescued before such extremes were necessitated, but you almost wish they hadn't been, just to see if he really meant it.

Big Savage also has the honor of being perhaps the only spot in the United States to have nuclear warheads dropped on it—although not intentionally—when a B-52 bomber carrying two twenty-four-megaton bombs crashed into the mountain in 1964. Happily, the fail-safe mechanisms on the weapons held.

The mountains of the Allegheny Plateau are the babies of the bunch, geologically speaking. The mountains generally get younger the farther west in Maryland you travel. It's all rather complicated, as geology usually is, but the short story is that the Maryland mountains in the Blue Ridge and Ridge and Valley provinces (the pattern was repeated, later, in the Allegheny Plateau) are built from the sediment of two ancient, Alps-sized mountain ranges that no longer exist. These old ranges were located to the east in what are now the relatively flat counties of Montgomery, Carroll and Frederick. They wore away a grain at a time until they became nothing more than sediment at the bottom of a vast inland sea. The thought of this lengthy, agonizing process happening more than once is rather impressive in itself. It's like singing "99 Bottles of Beer on the Wall" and when you get down to the last bottle, someone yells, "One more time!"

Submerged in the sea, metamorphic and aquatic forces compacted the sediments into sandstone and shale, and different minerals gave the rocks a variety of colors—red, white, green, gray, black. Organic matter in the lake's shallow swamps was concentrated into what we today know as coal. This pattern of mountain, erosion and inland sea was playing out well enough with a relative degree of structure until the continent of Africa came screeching across the ocean and crashed into the American continent. To my knowledge, no one was killed.

But its effect on the mountains bore a resemblance to a car that has been in a front-end collision. At the site of impact, there was a lot of splintering and fracturing, but further back it was more rumpled, or "folded," as they say in the geology business.

To the east, there were faults and wavelike folds. Three important gaps in South Mountain that allowed for the passage of settlers and provided key

military positions in the Civil War are a product of erosion along fractures caused by this crash.

To the west, thick layers of sediment that had been minding their own business were now caught in the jaws of a vice that—while less violent—still squeezed them into undulating waves of rock. A graphic example, Means said, is the Hampshire Formation, a band of distinct red sandstone and shale that first makes its appearance west of Clear Spring in cuts made for the construction of Interstate 70. The vein keeps you company on your trip west—the angle will become steeper as the wave begins to "crest," and then it will disappear altogether where it was sawed off by erosion, only to plunge back into view as the fold dips down to a bottom in its wavelength. Eight times it makes an appearance along Interstates 70 and 68. Besides the Hampshire, a vivid demonstration of folding rock can be seen in a deep cut into Sideling Hill through which I-68 passes. So visible and apparent are the folded layers of rock that a special rest stop and interpretive center has been carved for travelers into the side of the mountain. For geologists, that lesson in rock formation is a blessing and a curse. "Because of Sideling Hill people tend to ignore everything else, and there are a lot of other really neat places," Means said.

These wavelengths in the rock become longer and more shallow the farther removed one is from the collision site to the east. Whatever it means to the geologically inclined, this phenomenon has been a boon to Maryland coal miners. The veins of coal in Western Maryland run more horizontally than vertically, meaning that mineshafts more or less run parallel to the surface rather than burrowing deep into the ground—and requiring deep and dangerous mines. Because of this, Means said, Maryland mines have a better safety record than most adjoining states.

The rock along the tops of Maryland mountains is mostly resistant sandstone, with faster-weathering shale and limestone in the valleys. In some spots, the earth's heat has done interesting things with the stone, such as it did near Rohrersville, where limestone was cooked into marble—a commodity that was quarried in the early 1900s. For anyone who has ever attempted to blast limestone for a basement or waterline, it may seem curious that on the mountaintops there is sandstone rather than limestone. While it's true that limestone is harder on the face of things, it is an alkaline material (it's where lime comes from after all) that reacts in corrosive fashion when it comes in contact with rainwater, which is mildly acidic. Means likens its erosion to the old high school experiment of pouring vinegar into a beaker of baking soda.

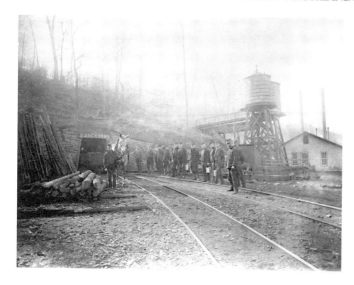

The Tyson seam of the Jackson Mine near Lonaconing. Miners worked the seam with picks, and four ponies pulled the coal to the surface. *Courtesy George's Creek Library.*

A marble quarry near Rohrersville operated for a few years following the turn of the twentieth century. The marble formed when limestone was superheated below the earth's surface. *Courtesy Edward Shifler.*

Some of the sandstone has also been cooked by the earth, hardening it considerably. So there it sits atop a mountain, when millions of years ago the grains most likely lined the shores of a primeval sea. West of Clear Spring, some of the mountaintops contain bright, white Tuscarora sandstone. "It must have been a beautiful beach at one time," Means said.

Conversely, plenty of material from the ancient mountains worked its way to the east. The eastern and western shores of Maryland's Chesapeake

Extracting lime to sweeten farm fields was a labor-intensive process, involving construction of a kiln. This lime kiln was built on the H.J. Speicher farm in the early 1900s. *Courtesy family of Mary Miller Strauss.*

Bay are essentially made up of thousands of feet of sediment from Western Maryland mountaintops. Geology has a rather peculiar sense of humor, it would seem.

The mountaintops in Maryland are wooded, since they are nowhere near tall enough to pop out above the treeline. But many rock outcroppings allow for fine views of the valleys below. High Rock on South Mountain once had a magnificent viewing platform perched on the formation. Today it serves as a launch for hang gliders soaring into the valley below.

Other trips to the valley happened with greater quickness. Allegedly. A rock outcrop on Wills Mountain near Cumberland is known as Lovers Leap (no self-respecting mountain range lacks for one or two of these). You can take just about any "tragic love leads to suicidal death" scenario you please, and it's probably been assigned to this particular Lovers Leap at one time or another, but my favorite is this: Young man falls in love with Indian maiden who, naturally, happens to be the daughter of a chief. The chief is not amused. He pursues the couple up the mountain and confronts them, leading the white boy to off the old man. This is problematic, since the couple, probably correctly, surmises that the deed will not be hailed as good news among the chief's fellow tribesmen. So rather than face the tribe's wrath, the couple arrived in a photo finish at the bottom of a cliff.

German immigrant Frederick John Bahr, who was in search of a remote spot where all the messiness of the Civil War could not reach him, purchased Lovers Leap and its environs in the 1860s. Bahr was an eccentric inventor with unbridled energy. Some of this energy went into his inventions, while a significant amount of the commodity was apparently reserved for kicking his family around and being generally brutish toward anyone who crossed his path.

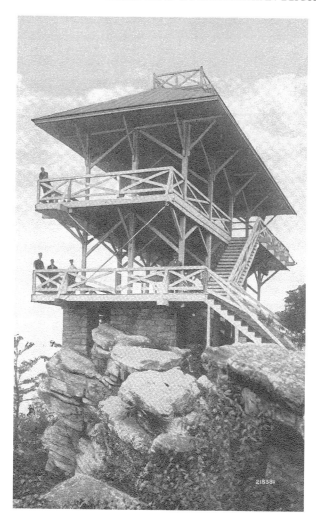

The observation deck on High Rock at South Mountain's PenMar Park. The tower offered a commanding view of the valley from Pennsylvania to Virginia. *Courtesy* Maryland Cracker Barrel.

Bahr's exploits are best remembered for the paddle wheel–powered blimps that he tried to sail in the stiff and tricky mountain wind currents. They made for better slapstick than transport. The first blimp burned while it was being filled, the second was shredded by his enemies' knives and the third was taken by the wind and crashed in some faraway forest. After that, he gave up on the project. He died in 1885, after which his meager log cabin atop the mountain was replaced by the glorious Wills Mountain Inn, which was built in 1899 and burned thirty-one years later, closing a rather dramatic era in Wills Mountain history.

For geological drama, however, it's hard to beat the notch in the mountains at Harpers Ferry, West Virginia, and the Narrows at Cumberland, where the

Massacres, Moonshine and Mountaineering

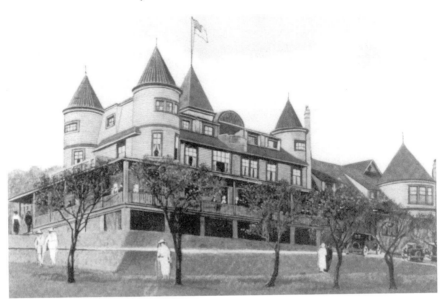

The Wills Mountain Inn, which opened as an Elk's Lodge on Wills Mountain near Cumberland, was built on the site of an old log home owned by an eccentric German inventor. *Courtesy Allegany County Historical Society.*

Potomac River and Wills Creek respectively squeezed through a particularly tight spot. The Potomac is an important geological feature—geological manipulator might be a better word—of the mountains, for it opened up the western hills to travel and commerce. In the chasms of Harpers Ferry and the Narrows, it's easy, if a little mind-bending, to envision the river carving, millimeter by millimeter, its way down through the mountains over the course of millions of years. But that may not be accurate. Certainly this scenario is one theory, but another holds that the river would have been there all along, and the mountains simply rose up on either side of it.

Because the folds in the mountains have been compressed, Means said that they have some spring to them, just like the celebrated bow of bow and arrow fame. When they are pushed, they have a natural tendency to push back. It goes without saying that this would happen quite slowly—over millions of years—giving the river ample time to wash away the rising sandstone in the riverbed, while the mountain grew on either side.

This was of little concern to the settlers heading west; what they did have interest in was a relatively level path by which to penetrate into the heart of the new nation. For that, the river would play a central role, and it would allow the Western Maryland mountains to bloom in ways that the aggressive driver of the African continent could never imagine.

21

NATIVE AMERICANS EXIT THE HILLS

Writing on the disposition and general attitude of the Iroquois, a Jesuit in Montreal lamented that he didn't have any ink black enough to describe the fury of this particular crew. The Iroquois, made up of the Six Nations, were sometimes referred to as the Romans of the New World, attesting to their sphere of influence that extended from their home base of upstate New York south to the Carolinas and west to the Mississippi. So even if they did not live in Maryland, this warring, hell-bent-for-leather tribe had reason to make contact with settlers from time to time.

In 1730, Thomas Cresap, an early pioneer of Western Maryland, had himself a sweet parcel of two thousand acres alongside the Antietam Creek in what is now Washington County.

From the store and Indian trading post that he established there, he bought up a massive stack of furs and hides, which he proceeded to ship back to England, only to see the vessel captured by the French, which effectively wiped him out.

Undeterred—Cresap seldom was—he moved even farther west to Oldtown, several miles from present-day Cumberland. How could he have known that this was on the Iroquois' main drag, which they used when they were heading south spoiling for a fight? Trading with the Indians was his vocation (Oldtown was one of Maryland's last Shawnee settlements), but this was ridiculous.

The Iroquois were more than willing to trade or, short of that, take by force if they didn't like the going rates. The Indians procured, in one way or another, a number of hogs for their pots and jokingly nicknamed Cresap "Big Spoon" for his role as their meal ticket. An angry Cresap petitioned the state legislature, asking for compensation for product pilfered by the Indians. His requests were met with stony silence. Generally speaking, though, the

Cresaps could look out for themselves. In their possession were a gun, two pistols, a scalping knife and a tomahawk. And these were carried by Cresap's wife. Who can imagine the arsenal sported by Cresap himself.

Such were the chance and uneasy relations settlers had with the Indians in the mountains of Western Maryland. Some writers describe the relations with the Indians as initially friendly up until the 1756 French and Indian War, after which there was an upswing in hostilities. This may or may not be the case. Allen Powell, who has written several books on the time period, says that it's doubtful that relations were ever terribly cordial; it was the settler's business to take land, and it was the Indians' business to try to hold on to it. This is what's known in divorce court as irreconcilable differences. "If there were any friendly moments, they were few," Powell said.

Farther west, Garrett County historian John Grant said that a fair amount of intermarriage took place and that a number of people in the area through the years could claim a degree of Indian blood. But this fraternization did not prevent a settler here and there from having to run his horse off a cliff to avoid a band of Indians who were dissatisfied about something.

Still, most of the Indian dust-ups occurred in Pennsylvania and farther out west. Tales abound in the Maryland mountains of random Indian attacks and kidnappings. Some are true, but many of these stories are unverified and some can probably be chalked up to folklore. Based on early pioneer writings, by the late 1700s panthers and rattlesnakes seem to have caused more consternation than Native Americans.

The Dutch explorer Jaspar Danckaerts traveled through Maryland in the 1680s, and even then he noted that Indians were few and far between. Danckaerts blamed European extermination, but historian Edmund Wehrle notes that "the relative paucity of Indians in Maryland was actually a permanent feature of the region and predated the arrival of the English by centuries." This is not necessarily atypical of mountainous regions in general. Mountains often make for good hunting grounds but poor dwelling places, especially in winter. Native Americans took deer and minerals for their arrowheads from the mountains, but they lived elsewhere. "On the eve of the white settlement of Western Maryland, Native Americans were simply not a factor in the region," Wehrle wrote. Shawnees inhabited parts of Western Maryland—mostly along the Potomac River—but on seeing the encroachment of the Europeans, many simply packed up and moved west. The outpost of Fort Cumberland, to some degree at least, discouraged attempts at retrenchment, and the fort did such little business in the way of Indian repulsion that it was abandoned by 1765. Those Indians who stayed around often succumbed to the white man's curses of smallpox or

alcoholism. By the time of the French and Indian War, Maryland governor Horatio Sharpe estimated there to be only 140 Indians in all of Maryland.

But the influence of Indians remained long after the genuine article was gone. The massive Fort Frederick, beautifully restored on the banks of the Potomac River near Clear Spring, was built in the 1750s by the colony of Maryland based on rumors of marauding tribes to the west doing the bidding of their French allies. General Edward Braddock had been defeated and killed in a fight near Fort Duquesne, and as his remaining troops limped back east, settlers panicked, realizing that there was nothing between them and the French-Indian alliance. "Paranoia swept not only Western Maryland, but the entire colonies," wrote Wehrle. "Fears swirled of Indian attacks, slave uprisings and Catholic plots."

Fort Frederick park ranger and historian Steve Robertson said that settlers had populated what is now Washington County because it was thought to be safe. "They didn't have to be 'frontier' men; they could just be farmers. They were defenseless because they weren't expecting anything like this."

Indian attacks came in "fits and spurts," Robertson said, a planned tactic to keep the settlers and the British off balance and offset a serious disadvantage

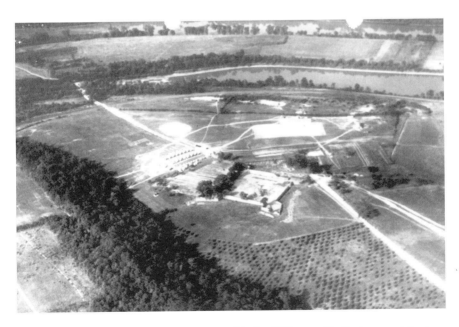

Fort Frederick, built by the colony of Maryland in the 1750s near Big Pool, was a defensive outpost during the French and Indian War. The ruins of the fort were rebuilt by the Civilian Conservation Corps. in the 1930s. In this photo, the CCC tents can be seen to the left of the fort. *Courtesy Fort Frederick State Park.*

in manpower. For a time, it worked. People abandoned their farms wholesale and moved back east. Indians got within sight of the fort only twice. They fired at one soldier and missed, but they took the scalp of another who was out cutting wood.

Rumor continued to exceed reality. Worried about their own skins, the Eastern Maryland power structure paid little attention to the concerns of the west. Cresap was not amused and threatened to march on Annapolis. He didn't, out of fear of losing his holdings to invading Indians. In the end, the Cresaps proved to be talented at defending themselves. Slowly, it became apparent that the enemy's strength had been exaggerated. A group of Cherokees allied themselves with Maryland and schooled the British in the finer points of gathering backwoods intelligence. "All of a sudden the whole situation is not veiled in darkness as it had been before," Robertson said. And as the British power began to prevail, the Indians—who seemed to have a particular talent for choosing the losing side in European spats —began to decide that discretion was the better part of valor. By the time Fort Frederick was completed—or nearly so, as the state ran out of funds in 1758—the British had captured Fort Duquesne and the danger of Indian attack had passed. However, even though the fort never saw major action, it still played a key role. "The point is that it worked, and did its job very well," Robertson said. (Along with providing an imposing physical presence, soldiers in the fort would line local fields and stand guard as farmers harvested their crops.) This job finished, though, Fort Frederick was abandoned and sold at public auction.

One curious footnote to the fort's history is that for much of the nineteenth and twentieth centuries, the fort was owned by a family of free African Americans who successfully farmed the grounds. The patriarch was named Samuel "Big Sam" Williams, who bought freedom for his wife and family in 1826. In 1839, he bought a farm near Four Locks on the C&O Canal. Meantime, his son, Nathan, was falling in love with a slave on an adjoining farm named Ammy, a woman whose freedom he purchased for $60. In 1860, the couple bought Fort Frederick and adjoining lands for $7,000.

During the Civil War, Ammy cooked meals for the Union troops, and Nathan sold them produce. Being a man of business, he also took the opportunity to sell vegetables to the Confederate troops stationed across the Potomac. This admittedly awkward situation was reconciled in Nathan's mind by the fact that he passed on information about the Confederates' activities to the North.

Inside the fort, Williams built animal pens and planted grapes, fruit trees and vegetables (this is keeping the deer away the hard way) to supplement

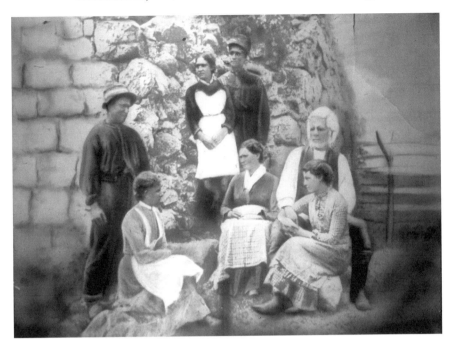

Nathan Williams, far right, and his family. A free black man, Williams bought Fort Frederick in the 1800s and raised crops within its stone walls. *Courtesy Fort Frederick State Park.*

his fields outside. Williams died in 1884, and the family sold the fort, which in 1922 became Maryland's first state park.

The Indians also had a lasting effect on the landscape. Deer prefer to browse on scrub and tender young saplings, so to encourage this new growth—and juice their hunting grounds—the Indians would burn large swaths of forest. Early settlers found many acres already cleared, which saved considerable work when preparing a field for crops.

Obviously some Indian names persevered, as the Conococheague Creek would attest, and several of the Maryland mountains owe their name to Native Americans, in one way or another, including, improbable as it may sound, Wills Mountain, which forms a backdrop for the city of Cumberland. Will probably wasn't the fellow's given name; when settlers couldn't pronounce an Indian's true name, they would assign English nicknames.

Writing for *Mountain Discoveries* magazine, Mary Meehan says that there are several stories about Will. He was recorded to history as Chief Will, although Meehan hasn't found any reference to him in early pioneer writings—which there probably would have been, were he a major player on the frontier stage.

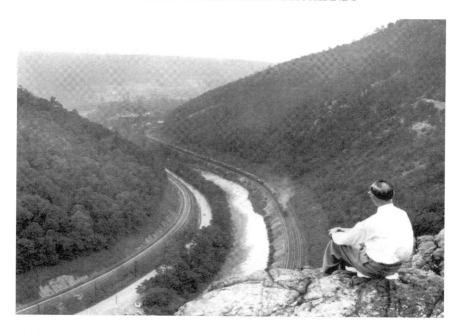

The Narrows at Cumberland is a thin slit in the Allegheny Front between the Wills and Haystack Mountains that allowed passage to the Allegheny Plateau. The mysterious Indian nicknamed Chief Will may or may not have been killed and buried on the mountain that bears his name. *Courtesy Allegany County Historical Society.*

In his 1878 *History of Cumberland*, W.H. Lowdermilk indicates that Will lived with his family and a few followers near present-day Cumberland probably in the mid-1700s. Lowdermilk's Will is a chummy sort, who palled around with the settlers and accepted trinkets in exchange for valuable property.

Thomas Scharf's Will was a bit less friendly. The nineteenth-century historian writes about an Indian raid at Williamsport, where several settlers were killed and two boys taken prisoner. The boys were taken to Will's Town, where the chief had no qualms about holding onto them for nine years. Meehan writes that at least part of this story is contradicted by research conducted by the settlers' descendants, who say that the dates and times don't quite match.

Finally, a newspaper article from 1907 by J.H.P. Adams tells of Chief Will leading a raid into Pennsylvania and capturing five settlers' wives. Carrying an infant, one woman couldn't keep up with the party as it made its getaway, so she and her child were killed and scalped. One of the settlers followed Will back to his home, where he shot and scalped the chief and buried him on Will's Knob. The surviving women were found in Canada and returned after six years.

So there you have it. Friendly Will, sneaky Will or evil Will; take your pick. As much as anything, the story of Chief Will illustrates the difficulty of getting to the bottom of settler-Indian interaction in the 1700s.

Another instance can be traced to the genesis of the name of Savage Mountain, which is either sinister or benign. In the book *Lily the Lost One*, written in 1881, Miss K.M. Weld recounted the following conversation:

> *"Can you," I said one day, addressing my host, "Can you tell me the name of each of these mountains? For instance, what is the name of the fine, large, thickly wooded one in front of us?"*
>
> *"That is Mount Savage, or Big Back-bone mountain. In olden times the early settlers called the Indians the savages, and as after a raid the Indians would always stop their retreat, and make fight against all pursuers on this mountain, the settlers called it the Savage mountain."*

Another story involves the Cresaps, naturally, and a deadly Indian fight on the mountain. (They are also credited with naming nearby Negro Mountain in honor of a black man who fought and died with their party against the Indians.)

The worm in the woodpile is an early surveyor named John Savage who roamed the woods in the 1730s. It's conceivable that the mountain, along with the town of Mount Savage and the Savage River, was named for him. But being a romantic, my sentiments are with the prior versions—no offense to John.

But the truth we do know is that following the French and Indian War most of the Indians had abandoned whatever claim they may have had to the Maryland mountains, leaving open a relatively safe passage to the white men headed west.

Chapter 3

SETTLERS FACE
AN UPHILL BATTLE

Early on, the Germans and the English each sent settlers to the Western Maryland (Scotch-Irish and Welsh would later populate the mountains farther to the west), but it was the mountains that dictated the terms. For the better part of a century, the occupants of the New World looked west to the rising hills and thought, "Why bother?" The Tidewater was comfortable and productive enough. But as more boats of settlers arrived, people of limited means looked for opportunity, and the only land that they could hope to claim or afford lay to the west in valleys guarded by stubborn mountain ridges. Sooner or later, these slopes, and the problems they represented, would have to be addressed.

"The terrain is always a big factor in any human endeavor," said Tom Clemens, history professor at Hagerstown Community College. "Mountains shaped the growth of the United States."

Much of the early movement into Western Maryland came not east to west but rather north to south. William Penn was encouraging settlers to move into his Pennsylvania colony, which they did. They filtered west until they hit the first major obstacle in their path, the Pennsylvania incarnation of South Mountain, and a part of the Blue Ridge. On Interstate 70 between Frederick and Hagerstown, the highway lopes across Braddock and South Mountains with such engineering aplomb that we barely recognize this section of the Blue Ridge as mountainous at all. They're more like soft, rolling hills. But to the 1700s traveler, they may as well have been Mount McKinley. On his western campaign, General Edward Braddock's horses were no match for the mountain that bears his name, so hundreds of men were forced to occupy themselves by cobwebbing their cannons in rope and hoisting them up and over the crest.

Braddock had at his disposal hundreds of soldiers. Early settlers might have had a cow. They took one look at the mountain and didn't like the odds. "Everything in those days had to be moved by muscle," Clemens said. "Any grade is going to be tough." Tough going up, but in some respects even tougher going down. The best teams were not necessarily the ones that could pull the load up the hill, but rather the ones with the wherewithal to brake on the downhill without being overrun by the wagon.

Facing a decision of clambering over rock and root or performing a ninety-degree change in course, they switched direction and headed south. They flowed down into Maryland, impressed by the fertile valleys east of South Mountain. As they wandered south, however, another geological reality was occurring: South Mountain was losing altitude. Several gaps in the mountain also offered tempting transit, not the least of which were the pass at the Pennsylvania line later known as the Sunshine Trail and a notch to the south where Braddock eventually improved, relatively speaking, the road on the way to what would become Pittsburgh. Many families (wanting no part of Maryland taxes and a growing border dispute between the colonies of Maryland and Pennsylvania) kept following the valleys south into Virginia, but some stayed, or rather squatted, since they could not hold title to the lands, which were not yet offered for sale by the colony.

While, or even before, the German peoples were traveling north to south, English settlers from the Tidewater were pushing over the ridges from east to west, according to Washington County historian John Frye. This was a process, because the big, open—and, more to the point, flat—estates to the east were fine and dandy and offered little incentive to move on, except for one

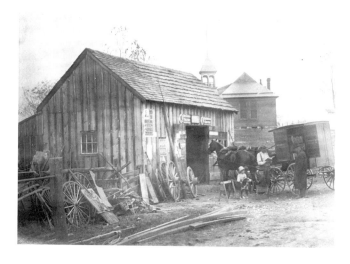

Bad roads were good for the business of producing and mending wagon wheels as settlers headed west along the National Road. *Courtesy Washington County Free Library.*

thing—modern agriculture had yet to come into play, and nutrient-hogging crops such as tobacco wore out the soil in short order. Today, farmers combat this phenomenon by rotating crops and applying fertilizer. But in the young nation, such measures seemed extreme when there was so much new property for the taking. "They would ruin the land and then move on," Frye said.

Obligingly, settlers began to trickle over South Mountain into an even broader, more fertile and better-watered valley than the one immediately to the east. Beyond, Western Maryland's mountains became decidedly more hostile, both in terms of topography and the dangers of Indian raids. The risks of western settlement are coyly alluded to in the name of a seven-thousand-acre tract west of the Monocacy River, purchased by Benjamin Tasker and labeled "Tasker's Chance" by a dubious investor.

Many of these settlers, however, were pretty tough and up to the challenge. They were eventually encouraged by the administration of the colony of Maryland, which offered financial incentives for settlement. The reason for Maryland's largesse was Pennsylvania. A nasty border question, which broke out into a war in the 1730s, led Maryland to try to populate the lands with Marylanders to ward off Pennsylvania encroachment. One of the ready takers had been the aforementioned swashbuckling pioneer Thomas Cresap, who was more than willing to take it to Pennsylvania "poachers." In 1736, he was captured by Pennsylvania and taken to Philadelphia to stand trial. Never one to miss the chance to stick the knife in a little deeper (figuratively or literally), Cresap pronounced Philadelphia to be "one of the purtiest towns in Maryland."

In the 1730s, the frontier movement west effectively halted for decades. There is a lazy creek west of Hagerstown called the Conococheague that snakes north–south to the Potomac River. It's not much to be impressed with, as waterways go. Yet through the mid-1700s, this may have been the most important watercourse west of the Chesapeake Bay, for it marked the very western edge of the frontier. To the east was some civility. To the west—lions and tigers and bears and Indians, oh my. John Wayne appeared in a movie about this unofficial boundary line once. Certainly there were pioneers, mountain men, military expeditions, hunters and settlements beyond the creek, but the general public was in no mood for daily bear and Indian fights.

Beyond the Conococheague, "The mountains were really impediments," Frye said. "There are seven ridges between Hancock and Cumberland," a distance of about forty miles.

On the more hospitable side of the creek, settlers—led by Jonathan Hager, founder of Hagerstown—wanted to break off from Frederick County with a

county of their own. George Washington had kicked around the area a good bit and made some friends, including the time he threw gasoline on British and French relations with his ill-fated expedition to Fort Duquesne. "He had passed through on his way to starting the French and Indian War—I want to emphasize that he was only trying to help," Clemens said.

In 1776, Washington was general of the Continental army, it is true, but up to that date he'd made a failure of it, having been unceremoniously booted out of New York by the British and offering a less-than-inspiring defense in the process. No matter; these South Mountain fathers named their county for Washington. "It was quite a leap; he really hadn't done much up to that point," Clemens said.

No doubt. Benedict Arnold had about the same track record at the time, but Arnold County definitely could have led to some facial egg down the road. Also, it strikes me that it is good for these early settlers that the colonists won. Imagine having to explain the name to a new, incoming British governor. "Uh, did we say Washington County? No, what we meant was Washing Machine County."

Washington "had been defeated at Brooklyn Heights, he'd been kicked out of New York; he was a bum. The Continental Congress was talking about replacing him," Frye said. But there was one important distinction: he was our bum, and we took our role models where we could find them. At the same time that the people west of South Mountain were forming their own county, so was a population forty miles to the east. The other leading Continental general in the field was Richard Montgomery. Up until that time, items in need of names had two sources for their inventory: Indians and British. To Marylanders, neither was a satisfactory option, so the people went with the colonials' two top officers in the field. The namesake of Montgomery County fizzled into near oblivion because he had the poor fortune to be killed in Quebec while leading an invasion of Canada in 1775.

Washington County worked out, though. To some—not to me, but to some—it was perhaps the first and only time that Washington County has shown any foresight about anything.

To these early settlers, South Mountain became less of an impediment than it did a way of life. Once the good land in the valley had been snapped up, poor dirt farmers began scratching fields higher and higher on the mountain's flanks. They learned what would grow and planted berries, peaches and apples. Many farmers had a "mountain lot" on which they cut timber and firewood. "You could make a living on the slopes," Frye said. "The mountain was very much a part of life, right up through World War II."

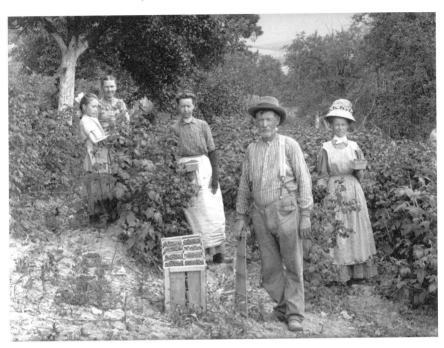

Because the Western Maryland mountains are relatively low, agricultural crops can be grown high on their flanks. Berries were a popular mountain crop, as shown here in a patch near Boonsboro. *Courtesy Doug Bast.*

Meanwhile, however, interest had continued to grow in the prospects for Western Maryland. The border dispute with Pennsylvania had been worked out in the 1760s by Charles Mason and Jeremiah Dixon, although it almost split the Maryland mountains in half. Maryland's southern border line was set by the Potomac River, and its northern border by a straight line between the thirty-ninth and fortieth parallels. While surveying, Mason and Dixon climbed Fairview Mountain near Clear Spring and noticed that the Potomac turned severely to the north and feared that Maryland's southern boundary might actually cross over its northern boundary. This potential, horrible inconvenience was averted when, at Hancock, Mason and Dixon breathed a sigh of relief as the river bent back to the south. But the margin for error had shrunk to less than two miles. Nevertheless, development was allowed to proceed without another boundary fiasco.

Tasker's son-in-law, Daniel Dulaney, took possession of Tasker's Chance and subdivided it, offering the parcels at attractive prices. Based on their reputation for industry, Dulaney successfully appealed to the Germans to populate the lands, which they did, encouraged by promises of religious freedom, a low

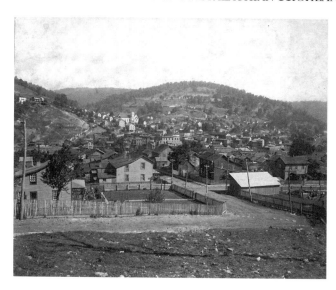

Settlements such as Lonaconing, shown here in 1908, were squeezed into mountain hollows and expanded with the mining of coal and iron ore. *Courtesy George's Creek Library.*

tax rate, the chance to acquire even more land and a knowable rule of law. They thrived, and as late as the middle of the 1800s some newspapers were still being published in German. The resulting city that grew out of Tasker's Chance was given the name of Lord Baltimore's son: Frederick.

By the time of the Revolution, most of the people who had settled in Western Maryland were fed up with imperial rule and the taxes and regulations that went with it. They began to agitate against the Crown. Naturally, the Cresaps were in the thick of it and drew an angry rebuke from the governor for stirring the pot. Further, according to historian Edmund Wehrle, the Germans were fed by rumors that the British planned to force the Church of England down their throats. Western Marylanders marched to war both to the north and south and acquired the positive reputation of having the hottest blood in the country.

From the war sprouted a key to mountain development. Soldiers were paid with fifty-acre plots of land, neatly laid out in early maps of Garrett and Allegany Counties. The maps were not drawn with consideration for accessibility or topography. This meant that a brave soldier might find himself the proud owner of fifty acres of vertical mountainside with no way to get to it. "The guys must have gotten up there and thought, 'Holy hell, look at this place,'" said Mount Savage historian Dennis Lashley.

But here was salable land, and speculators, sensing its value, began snapping up the lots for next to nothing. There was still that accessibility problem, however, which was about to be addressed in time, first by the National Road and later with mightier enterprises.

It can be argued that the two most significant historic events in the history of Maryland's far-western mountain development happened simultaneously in the cities of Baltimore and Washington. On July 4, 1828, Charles Carroll, the last surviving signer of the Declaration of Independence, helped lay the cornerstone of the Baltimore and Ohio Railroad (B&O). On the same day, President John Quincy Adams was in Georgetown to shovel the first bit of earth for "That Grand Old Ditch," which was to become the Chesapeake and Ohio Canal. (Adams's shovel bounced off a root, leaving the tool fruitlessly reverberating in his hands; for the canal, this might have been a sign of things to come.)

Civilization and commerce were on their way to the mountains.

That same year, William Carroll, a minor player in a major family, bought his first parcel of land in Allegany County. Tracts of land were assigned quaint names in those days, and some of Carroll's intent may be seen in

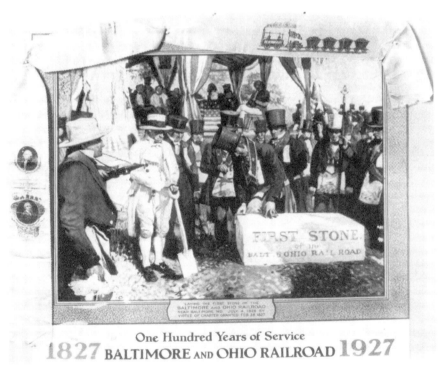

One Hundred Years of Service
1827 BALTIMORE and OHIO RAILROAD 1927

Charles Carroll, the last surviving signer of the Declaration of Independence, was on hand for the laying of the first stone of the B&O Railroad in Baltimore during an elaborate ceremony on July 4, 1828. Just south, in Washington, D.C., the first shovel of earth was turned on the same day for the C&O Canal. In terms of their successes, however, the similarities between the two projects ended there. *Courtesy Allegany County Historical Society.*

the names he gave to a couple of his holdings: "Canal and Railroad" and "Fortune Found." (The way it played out—and were Aeschylus writing the script—the next parcel might have been called "Fortune Unfound," but that is to get ahead of the story.) Carroll, along with his in-law Richard Caton, snapped up just about every free lot they could through the next decade. "If there was available land between Hancock and Flintstone, one or the other would grab it," wrote John Mash. "It was almost like a two-headed monster on the loose."

The logic was sound. Natural resources are of little value if there is no way to get them to the markets. All of the coal in Allegheny County was worth little if it had to be hauled out one horse-drawn wagon at a time. But with the easy transport offered by the approaching canal and rail, these resources would be very valuable indeed.

Carroll's problem was that he was often unable to pay for the land that he contracted upon and therefore frequently was unable to take possession. In Mash's book, *The Land of the Living*, he details a fascinating list of transactions, great plans and great disappointments. Carroll continued to buy hundreds of acres at a time ("Buck's Horns," "Beautiful Valley," etc.) and some so small that you wonder why he bothered (the one-acre "Outhouse Lot"). But even one acre would provide for one heck of an outhouse, one supposes. Carroll outlined plans for a grand resort that he called "White Sulphur Springs" after the grand palace in what was then western Virginia. With the creativity that comes with "Outhouse Lot," you can't help but be a trifle disappointed that he felt compelled to copy the name of an existing establishment. The notion of healing waters being big at the time, Carroll hoped to cash in on the trend and sold shares for the project. Unfortunately, he didn't sell many, and nothing ever came of the land, which is now part of the Green Ridge State Forest.

Some of these parcels came with improvements, which were not worth much. The value of a sawmill was listed at two dollars in one transaction, and a cabin on the same lot was assessed at seventy-five cents. So there is an element of today's foreclosure market in these bills of sale.

Of course, it was the minerals and timber that held the real value, if they could be tapped. Carroll tried. At Devil's Ally he established a newfangled steam-powered sawmill. In the end, though, he was a capitalist who lacked capital. An uneasy tug of war existed with his wealthier relations, as Carroll tried to get them financially interested in the experiment. When Charles Carroll died and divided up his estate, the rest of the family called in the chips.

Nevertheless, when the dust settled, the Caton/Carroll enterprise was in possession of perhaps thirty thousand acres and the town of Orleans (for which townsfolk were charged rent for the privilege of living in the settlement). The problem, Mash notes, is that most of the land "was very rugged and therefore inaccessible."

Another problem was with the mountain surveys themselves. Tracts were surveyed and resurveyed, and they were long on lines and short on specifics. Property boundaries in the mountains were foggy and remain so right up to modern times. In one instance, an entire (and rather substantial) parcel simply disappeared. It was there on the books, but not there in terra firma terms. Even today, no one knows where this chunk of land went—moved west with everyone else, perhaps—although it is suspected it has become part of state forestland somewhere, so it is of little consequence.

Goofy surveys are believed to have led to the name of one Western Maryland mountain town. In 1774, Lord Baltimore had opened up his vast landholdings west of Cumberland for settlement. Carroll and Caton, of course, were not the only early land speculators—Brooke Beall and William Deakins Jr. were two others. Deakins and his surveyors carved out a 682-acre tract between the branches of Bear Creek of which they were pretty proud, until Beall showed up, claiming that he had beaten Deakins to the punch. As proof, Beall pointed to axe marks that he had blazed on the trees. Given that this was the wild, lawless western frontier, we might gleefully rub our hands in anticipation of a knife fight and a lifelong blood feud. Unfortunately, the two men were friends, and Deakins cheerfully admitted that he must have claimed the same land by accident. Thus was born the settlement of Accident, Maryland. In her history *Flowery Vale*, Mary Strauss writes that this is the most likely source of the town's name, although there are competing stories. "At least it checks with local land records." Such as they were.

By the 1800s, the land issues were beginning to work themselves out and transportation was on its way. Until it arrived, however, much of the land speculation was, well, just that. So for a few decades there remained time for the glory days of that most marvelous of mountaineers and American icons: the early, deerskin-wearing, rifle-toting frontier pioneer.

MARYLAND'S DANIEL BOONE

Meshach Browning was having trouble winning over approval of a stubborn father-in-law who did not bless his marriage, to say the least, and what better way to gain favor than to send the newly acquired relative a quarter of bear meat?

On the Western Maryland frontier at the turn of the nineteenth century, there could hardly be a better gift. At least not one that could be afforded by the likes of Browning.

The feats of the great pioneers such as Cresap and Dulaney have been well-documented, or fairly well documented, but what of the common clay—the men and women who moved west in anonymity and scratched out a living in the wild woods? Their tales are seldom told, largely because many of the early settlers couldn't, or didn't bother to, write.

One who could and did was Meshach Browning, who wrote the book *Forty-four Years of the Life of a Hunter* with a turkey quill pen.

Browning reports killing so many deer (two thousand), bears (four hundred) and panthers (fifty), and includes so many stories, that today it seems incredulous (knifing bears to death and fighting bucks with his bare hands), and serious scholars can't help but arch an eyebrow—despite numerous testimonials from contemporaries as to his veracity, which are duly printed in the book's most recent edition. But Browning hunted the game-rich forests for forty-four years, so divided out, these numbers may not be all that far off.

But if Browning did gild his hunting accomplishments, the fabric of his story seems, to me at least, to be genuine enough. The frontier was about all he knew, and the day-to-day life that he relates gives the flavor of a day when the nearest neighbor might be miles away.

Primarily, his is a hunting book. In fact, Browning appears to get bored when he's relating the more mundane facts of daily existence. In between bouts of stabbing bears to death, for example, he will let it slip that he now has an additional three children in his family—a fact he had neglected to grace with an account earlier.

Yet it is the daily routine that is more interesting after all the myriad deer guttings begin to blur.

Browning was born in Frederick County, Maryland, in 1781, to small-farm parents "who had little to recommend them in this world but an unsullied name, and known only as being strictly honest, industrious and truthful."

When Browning was a toddler, his father died, leaving his mother to care for four children whom she couldn't afford. A brother was given to a family named Lee to raise, and his mother scraped by, raising vegetables, spinning, sewing and knitting. When Browning's sister married, his mother resolved to take her two remaining children and join friends in the west, near Flintstone. She set out to find her oldest son but couldn't.

A "large negro" loaded a wagon with their possessions, and they headed west, "whip cracking, mother crying, negro cursing and swearing until we were on the main road to Frederick."

The National Road was still a couple of decades away, and the wagon path over the mountains was wanting for maintenance. On a particularly rocky stretch on the crest of Sideling Hill, the wagon lost purchase and rolled down the mountain. Just about everything that the Brownings had of value was lost—barrels of rum, sugar and salt were smashed to splinters. As the family scooped up what it could of the sugar and salt mixed with leaves and dirt, the driver cupped his hands and scooped up what he could of the rum where it had pooled. Not the best of new starts.

But it was a struggle for any poor settler moving west in the 1700s. Aside from a flurry of unpleasantness at the time of the French and Indian War, the Indians were a small factor, although rumors of attacks and kidnappings kept the pioneers on their toes.

More critical to the effort was clearing a spot of land, throwing up a tiny log cabin and getting a crop in the ground. Uneducated as they otherwise might have been, the new farmers of the west, like farmers today, were keenly aware of commodity prices that were printed in the paper or posted in the local tavern. They read the sheets and planted accordingly.

In the broad fertile valleys in Washington and Frederick Counties, an industrious farmer could gradually expand his holdings. Edmund Wehrle writes:

Massacres, Moonshine and Mountaineering

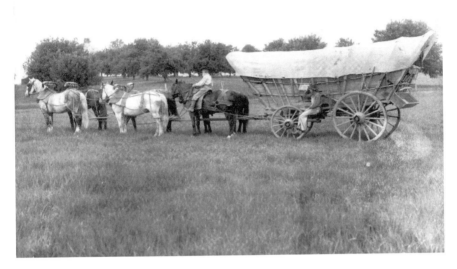

The celebrated Conestoga wagons, or prairie schooners, lined the National Pike as settlers headed west through the Maryland mountains. *Courtesy Allegany County Historical Society.*

Credit networks among the settlers helped the Germans establish themselves and, sometimes, expand into more commercial farming. While most farms remained family operations, more prosperous farmers did hire servants and some bought slaves. The first generation of Catoctin area farmers thrived despite adversity. Land holding at death frequently exceeded 400 acres.

A cabin built by a creek in a hollow might one day be replaced with a fine stone house on a knoll with expansive views of the valley.

As Browning's family discovered, however, life to the west—where valleys were narrow and fields were often rocky—was a different proposition. Settlers to the east depended on a plow; Browning would come to depend on a gun.

Arriving in Flintstone, his family discovered a neat little tract of twenty acres "that was too small to attract the notice of others" and, with the help of friends, threw together a small cabin. Then all hands, including the children, set about clearing four acres of forest and planting corn in the clearing. A small garden was sown with pumpkins, cucumbers and other vegetables for the table.

While still a young boy, Browning was plucked from his mother by an aunt and uncle who had no children of their own and taken west. Crossing the mountains with cattle and chickens in tow, Browning got his first glimpse of Cumberland, which in the late 1700s was a collection of twenty cabins surrounded by dense fields of corn. The convoy continued west and settled in an agreeable area where Browning was quite content until the unexpected happened: after twenty years of marriage, his aunt had a child. "This knocked my nose clear out of joint, for I was soon denounced as lazy and everything but a good boy."

The aunt ("She was an even-tempered woman, for she was always mad") became physically abusive and Browning was miserable, save for a life-altering experience—he shot his first buck. Feeling relatively self-sufficient, Browning headed for the Ohio territory, where he killed his first bear. He returned after four months, drawn back largely by the charms of a young woman named Mary, who would become his wife. They married at age eighteen in 1799, much to her father's chagrin. This was in the days before therapy and anger management, and the man dealt with his issues by booting the couple out of the house. Mary felt the timing might not be right to ask her dad for one of the family cows, so the early going was rough.

"I had been preparing a home for her, having traded my horse for a small squatters farm with 15 or 20 acres of cleared land, three acres of wheat standing in the ground and a good little cabin," wrote Browning. "But not a cow had I to give us any milk, nor a bushel of grain, not a pound of meat, it being very scarce and not to be obtained without money; but I had not a dollar."

By now, Browning had quite the reputation as a marksman and a hunter, and this would save the day. The youngster bagged a bear, and after sending a quarter to Mary's father, "who was quite fond of bear meat" (the kind gesture didn't do any good), the couple boned and pickled the rest of the bear and packed it in barrels set on a dirt springhouse floor. Thus preserved, they had meat to last through the summer. Even though Browning valued their total possessions at less than twenty dollars, with meat, milk, bread and each other, "It is probable that a happier man and wife were nowhere to be found."

Things were looking up. Browning traded his favorite rifle for a cow, which supplied them with plenty of milk and butter. This barter and exchange—a horse for land, a gun for a cow—was typical of life in the Maryland mountains, where little hard currency existed. A bear or deer hide might bring a little money at a trading post, and a bounty of eight dollars existed on wolves, but short of that, trade was the primary way of meeting needs.

Massacres, Moonshine and Mountaineering

Since hides and meat had value, Browning was eventually able to parlay his hunting skills into a more diversified farming portfolio, including three cows, eleven sheep and a young colt. The land produced fine crops of corn, potatoes and wheat. Just then, however, another danger of the frontier, which had nothing to do with Indians or wolves, raised its head. A claim was made against Browning's small farm, and the apparent new owner ordered him to leave. Browning called it a false claim, but having no money to fight in court, he and Mary decided to move to the glades to the west, which consisted of vast acres of natural, sometimes marshy, grassland. For once, his father-in-law lent an assisting hand. Wishing to see the young couple gone from the neighborhood, he helped them pack.

As he was writing his memoirs fifty years later, Browning complained that the glades had been all but ruined by farmers to the south, who would drive in large herds of cattle to graze for the summer with no care toward conservation. But in his early years they were stunning—sprawling meadows of tall grass flanked by mountain ridges of chestnut and white oak. (Had he been able to peer into the future, he would have been more despairing that his beloved chestnuts would vanish in the early 1900s, the victims of a devastating blight. Perhaps more than any other tree, the chestnut had aided western expansion. The rot-resistant wood was perfect for homes and fence posts, and the nuts fed both men and the birds and animals they hunted. The tree dominated the mountains of the East Coast, but by 1940 the entire population of mature chestnuts had been wiped out.)

Their new residence was an abandoned cabin that had no door, chimney or floor and whose rafters had been torn down and used as firewood. As they crossed the threshold, they were welcomed by a rather sizable rattlesnake. On her way to the spring, Mary was confronted by five wolves who demanded to see her papers and might have become a bother were she not traveling with their trusted dogs.

They were helped by another family, however, that was thrilled to have a neighbor so close by—close-by neighbors being defined in those days as anyone living within five miles of you. There was plenty to do. Browning built a new table to take the place of the old one, which was a strip of maple bark tacked down at the corners to keep it from curling. He also laid in a floor. Here, Browning proved a better hunter than carpenter. He split boards, but the first batch was so uneven that he decided that this would have to be where the bed would go so they would be covered from sight. His second load of boards went in along much the same unparallel lines. Finally, Mary remarked that the whole floor would have to be under the bed and that she would once again be left to stand on dirt.

Browning appreciated the fact that she could keep her humor while living in the wilderness. "I have often thought what some of our young ladies in these days would do if, placed in a like situation at 20 years of age, they were located amongst bears, panthers, wolves and rattlesnakes. I would like to see a few of them try, just to learn how they would come through what she so bravely stood up to for four or five years."

After a few more domestic improvements, Browning was ready for recreation, which for him was a hunt. He was happiest when "like the sheet that was let down to St. Peter, we had nothing to do but 'Rise Meshach, slay and eat.'"

The frontier mountains offered their hardships but also their bounty. As for Browning, this abundance of game kept many pioneers going. The land was rich in deer and bear, and the streams were filled with trout. Turkeys grew fat on berries and nuts. Maple trees could be tapped for sugar. Numerous beehives were there for the raiding, each hive yielding between two and ten gallons, and a pot of honey was almost always found on pioneer tables.

Browning happily describes dozens of bear kills, which generally involved a crippling shot—rifles in those days did not pack the punch that they do today, and the powder wasn't always of the best quality—and then release of the dogs, which would keep the beast at bay. Not wishing to risk a second shot for fear of hitting a dog in the chaos, Browning would finish off the bear with a knife to the heart. This may not have been standard hunting procedure for the Western Maryland pioneers, for Browning admits that many regarded his ursine infighting as daft. He wasn't entirely devoid of sense where panthers were concerned. These beasts, which could be twelve

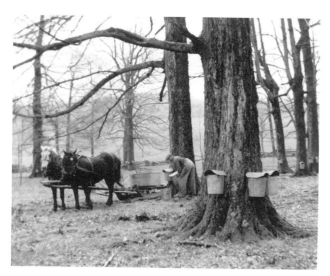

In late winter, sugaring was a popular endeavor. This maple bush was owned by Foster Yost near the town of Accident. A note on the back of the photo mentions that the horse's names were Pat and Fred. *Courtesy family of Mary Miller Strauss and the Ruth Enlow Library.*

feet long from stem to stern, were not to be trifled with, and to that end Browning was not above turning tail. "If any man would run at all, I think [a panther] would have been as good a cause as he could wish for."

Browning found a ready market for his many deerskins, the product being the predominant pioneer fashion at the time. He could trade skins for flour and bear meet for wool and flax. Hunting season was generally considered to be the best in the last three months of the year, when the animals were fat and before the bears hibernated for the winter. In that time, enough meat could be salted away and enough hides could be traded for grain to last the winter. Browning might be in the woods for a week on a hunt, through all manner of bad weather. Once he awoke to find his hair frozen to a tree. In warmer weather, one had to watch for snakes. That meant wrapping the lower legs in braided grass to ward off bites and sleeping with your head on the dog, which could be counted on to awake at the slightest slither.

What hunting surplus Browning had served to build up his herd of cattle and sheep. Occasionally a sheep would be lost to a wolf, which was no matter, since Browning could shoot the wolf which, in cash terms, was worth more than the sheep.

Once again, though, luck on the frontier proved fickle. Browning planned to move farther west into the Ohio territory, so he sold his modest herds of cattle, hogs and sheep for a promised $175. But when he went to collect his cash, the buyer had none and the animals were long gone. It got worse. Two of Browning's mares got into a fight, with one kicking the other to death. Disease claimed three other horses, and his last remaining mare was sick. "There I was with not a living beast except that sick mare and a dog," he lamented. The trip was cancelled, and once again the Brownings had to start from scratch. The great hunter was thrown into a bout of depression so severe he could not bring himself to set foot in the woods.

It was Mary who righted the ship. She walked five miles to the nearest trading post, and on promise of future payment, for she had no money, she bought two pounds of powder and four pounds of lead. These she brought home to her husband, along with the order to "cheer up." Browning took to the forest and in four hours had killed three bears, including the largest one he was ever to see. He roasted the liver of one for his supper and went to sleep under the stars, once again content.

In all, Browning relates a good life that reveled in simple pleasures, none that was as valued as much as good conversation over a horn of whiskey, presumably because neighbors were so sparse and company was enjoyed so infrequently. He reports that the majority of frontiersmen were federalists loyal to Washington and Adams. In his region there was but one Democratic

Republican out of the Jeffersonian mold, but this man's presence was valued, an opposing view being necessary for a good argument.

Browning had a large family that, outside of Mary, he refers to only vaguely—although he does express pleasure over coming home to the wife and kids after a particularly long hunt. If he ever felt lonely or isolated he does not mention it except, perhaps, as it pertained to medicine. In far Western Maryland there were few, if any, doctors or drugs. There could be nothing done for illness or injury, except to wait it out. Browning was afflicted with rheumatoid arthritis, the only remedy being to lie in bed for months at a time until the spell went away of its own course. Mary became severely ill on one occasion and probably only survived because a friend offered to pick up some medicine on a trip to Frederick. In 1835, or thereabout, Mary was thrown from a horse and was never the same again. She lived, mostly bedridden, for three more years in states that ranged from discomfort to agony. She died on January 29, 1839.

From that date, Browning never seriously hunted again. Even 170 years later, his anguish seems as fresh as if were newly penned. Isolated in the middle of an often-hostile wilderness, he and Mary faced together challenges that today we cannot imagine, when all they had with which to rise to these challenges was each other. Through the winter months, they might have been snowbound in their cabin for months. They lived by the whim of nature and operated under a set of rules that were beyond their control. When Meshach went off on a hunt, Mary could never be sure he would return alive. Her life was hard and she had to work relentlessly, but she stood by him through it all. He knew it, appreciated it and loved her all the more for it. In some ways, she was the only dependable part of his life. Browning makes clear that she was every bit the hero of the western movement as any male contemporary, and the same could be said for many frontier women whose names we do not know and whose pictures we have never seen.

In his late seventies, Browning wrote his memoir on the eve of the Civil War and died shortly thereafter. Whatever stock one wishes to place in his hunting records, his is a remarkable story. Cut to the ground multiple times, he always rose again and triumphed. He began to acquire land and, on trips to Annapolis to record his new holdings, would sell wagonloads of meat and hides. But for all his success, he never seemed happier than in his floorless cabin in the glades, where his wealth could be counted on the heads of a few animals.

"I say, who could not be happier than I was at that time? It would be difficult to find a man who had less trouble and enjoyed more pleasure than I did until the last year of my residence in that place." Given the number of wolves and rattlesnakes, that is quite a statement.

A ROAD PIERCES
THE WILDERNESS

While it may be true that drinking and driving don't mix, it is also true that liquor had a hand in building what became known as the Old National Pike, an artery that opened up the Western Maryland mountains and, for two or three wild and woolly decades, was the life of the new nation's transportation party.

Technically, the National Road ran from Cumberland to Wheeling, West Virginia, since it was the first highway in America to be paid for with federal funds. In the local vernacular, however, the term has been expanded to include the old highway leading west out of Baltimore. In a sense, this is accurate, to the degree that the roads escorted a nation from the coast to the interior. "This road was heavily used from the start; the great migration from the American seaboard had begun," wrote Mark Zeigler in papers on file at the Hagerstown public library.

So with the understanding that the byway from Cumberland to Wheeling is the true National Road, I beg permission to use the term to refer to the whole shooting match on the scholarly grounds that it's just easier that way.

In the late 1700s, roads systems were a mishmash of farm lanes, military paths and slightly improved upon Indian trails. General Edward Braddock is credited in some circles for getting the ball rolling on a cohesive route west when he set out to confront the French in 1755 at Fort Duquesne near present-day Pittsburgh. But even here, some credit needs to go to transitory Native Americans, whose paths were frequently improved into roads by white settlers. In this case, Braddock's route largely followed the Nemicolon Indian trail. Whatever the case, Braddock left Frederick in April 1755. "Little did he realize as he entered the foothills of the Allegheny mountains how arduous the trek over the peaks would be," wrote Thomas Abbott and John Baar in a collection of Washington County archives. His army required a twelve-foot

swath through the wilderness, and "the forests rang out for months with the echo of woodsmen's axes, and at night entire valleys and hills were dotted with the campfires of weary men."

After this epic, three-month struggle through the wilderness where an advance of five miles was considered a good day, Braddock punched through to the Monongahela River, only to get his tail whipped by the French. Oh well.

The military embarrassment aside, he had effectively taken a nail and scratched a thin line through the forests and mountains to the west. The route was known as "Braddock's Road," although in 1894, Thomas Brownfield Searight argued it would have been better known as "Washington's Road," since he "passed over it in command of a detachment of Virginia troops more than a year before Braddock even saw it." As a highway engineer, Braddock's 1755 venture was about as successful as his military campaign. At Cumberland, he went up and over the mighty Wills Mountain rather than take the easier route through the Cumberland Narrows, but he got the point across: it could be done.

It just couldn't be done quickly or easily. At the close of the eighteenth century, a few hardscrabble farmers were growing what corn they could in the mountains around Cumberland. However, sending a bulky wagonload of low-value grain back east over the rocks and through the mud was a tedious and ponderous venture, and when all was said and done, there was no money in it. The answer, of course, was to distil this corn into whiskey, which packed better and fetched far more cash. It was the equivalent of transporting a couple ounces of gold as opposed to a ton of ore.

That worked out well enough until 1791, when Treasury Secretary Alexander Hamilton, needing to pay down the Revolutionary War debt, talked Congress into taxing whiskey. The result, as we know, was a western rebellion that was put down by President Washington himself in a show of federal authority. He did offer some concessions, though, one of which was to improve the Western Maryland road to make it easier for farmers to ship corn for its originally intended purpose.

The cause, and the immediacy, of a national road got another boost in 1803 with Jefferson's Louisiana Purchase. In a blink, there was a new urgency to be able to travel to the interior, supply western settlers on our new property and connect with New Orleans and other ports on the Mississippi.

Road construction began in earnest—or at least as "in earnest" as Congress ever gets. In 1806, the government approved $30,000 for preliminary study, but actual construction didn't get underway for another five years. The road reached Wheeling in 1818, at a total cost of $7 million—or close to $100 million in today's dollars.

The idea for the road is generally attributed to Henry Clay, although this is disputed. What's not in doubt is that Clay became a great champion of the idea. "I have myself toiled until my powers have been exhausted and prostrated to prevail on you to make the grant," he told a dubious Congress.

Meanwhile, things were moving a little faster to the east, where turnpike companies and banks were footing the bill and recouping the cost through the payment of tolls. This segment became known as the "Bank Road," and financial institutions were awarded "valuable considerations" from the government for funding the project—valuable considerations meaning that if they played ball the government let them keep their business licenses. Tollhouses were common along the roadway, although some schedules mentioned that payment was not required if you were heading to a funeral or to church. By 1805, an improved road led from Baltimore to Boonsboro —and stopped there, for lack of funds. The politics that got the route to Boonsboro in the first place were hot and heavy. Prior, most of the westbound traffic had used Fox's Gap to the south and traveled through Sharpsburg and Williamsport. The National Road pitted these two communities against Boonsboro and Hagerstown for the right to be on the main drag.

The classic tollhouse on the National Pike. Travel on the road was free for those headed to church or, as it was the least they could do, a funeral. *Courtesy Allegheny County Historical Society.*

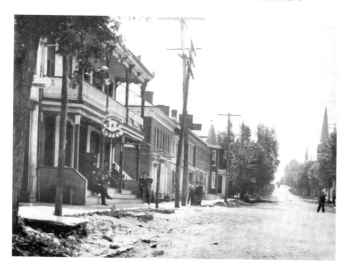

The National Road through Boonsboro would have passed by what was originally known as the Eagle Hotel, which was built in the late 1700s. After falling into a severe state of disrepair, it was purchased by author Nora Roberts and converted into a classy inn. Twice. On the eve of its completion in 2008, a propane heater started a fire, and the old hotel burned down. At Roberts's insistence, however, the old stone walls were saved, and it was rebuilt again. Opening in 2009, it is now a town showpiece and no little source of pride among town residents. *Courtesy Doug Bast.*

Road construction continued to the west, from the Conococheague Creek to Cumberland and from Hagerstown to the Conococheague. Something of a "golden spike" was used to celebrate the connection in the form of a fine stone span over the creek. West of Cumberland, engineers had agonized over a route, in a landscape where there were frequently few good options. A commission appointed to plan a route reported to Congress: "The face of the country within the limits prescribed is generally very uneven, and in many places broken by a succession of high mountains and deep hollows too formidable" to be directly crossed. "Reducing hills and filling hollows on these grounds would be an attempt truly Quixotic." So the road was built up the mountains at an angle, even though it "imposes a heavy task of hill-side digging."

These old reports are fascinating reading, by the way, and give you the idea that governmentspeak is not a new phenomenon. The land did not have hills, it had "an inequality of the surface."

Some of the road had to break new ground on land that had never seen so much as an Indian trail. The "rugged deformity of the grounds" again required a traverse of the mountains instead of an "up and over" approach.

The problem was that it was hard to make the required cuts that would make the road wide enough for two wagons to pass. Commissioners fretted over both the logistics and the cost. One silver lining to the mountains was an abundance of rock that could be crushed and used for the roadbed. There was no need to haul in aggregate from far-off locations. Still, they estimated the cost at $6,000 per mile, not counting bridges.

Meanwhile, still nothing was built between Boonsboro and Hagerstown. Stagecoaches that sped along at a handy clip bogged down in the ten miles that separated the towns, which by 1820 was the last missing link from Baltimore to the Ohio River. What should have taken an hour tops took stages five to seven hours.

The road was finally improved, but not before Boonsboro got one more distinction out of the situation. Scotsman John Loudon McAdam had just figured out a revolutionary road-building process that employed small stones that were compacted to seal out rainwater. The turnpike company bought into the idea, and thus Boonsboro-to-Hagerstown became the first stretch of road to receive a macadam surface. (Later, motor vehicles tended to break down the loose stone, so a spray of tar was used as a binder; this was known as tar-bound macadam, or tarmac.)

The completion of the national road led to an amazing era that lasted for three decades.

The road was a marvel, paved all the way, with signature stone-arch bridges (many in the middle of the wilderness) and artistic markers for every mile. The eastern population rushed to take advantage. A nostalgic *Harper's Monthly* revisited the glory days of the old road in an 1879 article:

> *The octogenarians who participated in the traffic will tell an inquirer that never before were there such landlords, such taverns, such dinners, such whiskey, such bustle or such endless cavalcades of coaches and wagons as could be seen or had between Wheeling and Frederick in the palmy days of the Old National Pike; and it's certain that when coaching days were palmy, no other post road in the country did the same business as this fine old highway.*

In 1842, a stage could run between Baltimore and Wheeling in the unheard-of time of forty-two hours. Assuming one were in a hurry to get to Wheeling.

It was a road of color and colorful characters. Black-and-white photographs do not do the stagecoaches justice. They were brightly painted works of gaudy art, with gilded trim and whip-cracking drivers, who did

not need to have to have their arms twisted to engage in races with other stages. Passengers were free, if not encouraged, to gesture, jeer and shout insults at the competition. Coach rage was common among the drivers. The passengers were about as bad. As a game, they would dangle a piece of mail out the window to see how far the recipient would chase the stage before crumpling from exhaustion. The pace was frantic. Horses strained to tug the stage up one side of the mountain, then ran like the blazes to keep from being run over by them on the downside. How did they keep from crashing? They didn't. "The overfast and reckless driving often led to disaster," wrote one early onlooker. One victim was presidential contender Henry Clay, who found himself tossed into a rock pile near Uniontown. Unperturbed, he lit a cigar and remarked that the Clay of Kentucky had mixed with the limestone of Pennsylvania.

Actual presidents—Zachary Taylor, James Polk, Andrew Jackson, William Henry Harrison—were frequent travelers, as were frontiersmen Davy Crockett, Daniel Boone and Sam Houston. When a stage would clatter into town, the residents would turn out to see who was aboard. The arrival of the stage could be foretold by tempting smells wafting from the tavern kitchen and a flurry of activity by the staff as they set plates and lined the bar with shot glasses. Supper cost a quarter, whiskey a nickel. Little beer or ale was to be had, everyone preferring the stronger stuff. But the whiskey was so good and pure—and this is commented on with some degree of awe at the time—that it didn't cause the imbiber to see spiders in the morning. The food was legend: "The eating was the cream of the earth, sir," one old-timer told *Harper's*. "I dined at Delmonicos last week and my dinner was nothing to the venison cutlets and the ham and eggs and Johnny cakes of the pike."

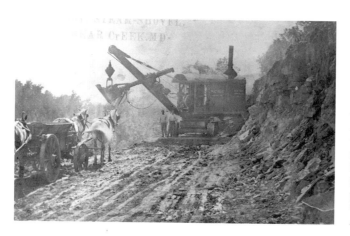

Transportation was necessary for development of the mountains, but roadwork could be a chore, as illustrated by this project near Bear Creek. *Courtesy Ruth Enlow Library.*

Massacres, Moonshine and Mountaineering

The circumspect writer put it all down before dryly noting that "tastes are variable and unaccountable."

Most of the traffic was headed west, as evidenced by the fact that the taverns—one every mile—were mostly sited on the north side of the road. Large signboards on sturdy posts with golden letters "ogled the wayfarer from the hot road-bed and gave promise of good cheer," Searight wrote.

Business boomed as the nation headed to the great unknown. Subtract out the snowcapped peaks, and the Allegheny Mountains—even fifty years later—drew comparisons to the Sierra Nevadas for their precipitous drop-offs and wild countryside. From Sideling Hill, the mountains resembled "ridges beyond ridges that look like the vast waves of a petrified ocean." It was not a deterrent. Great herds of sheep and cattle raised clouds of dust that could be seen for miles. Wagons traveled so close to each other that it was said that the beasts of one could be seen snacking on the grain inside the wagon just ahead of it. Conestoga wagons, the famous "prairie schooners," sailed one after the other. In Washington, Pennsylvania (curious that they kept the name after George dealt so sternly with them during the Whiskey rebellion), a salesman peddled cigars that, in the spirit of the times, he called "conestogies." This name proved too cumbersome, and the "stogie" was born.

"So much of the very life and breath of the history and people of the United States are inexorably bound up in each and every mile of the road as it proceed[ed] westward," wrote Abbott and Baar. Men ate, drank, guffawed and flirted with the pretty tavern maids. They poured money into the towns and settlements along the route. Even in the wilderness, "The traffic was as dense and as continuous as on the main street of a large town," according to early accounts.

Searight concurred:

> As many as 24 horse coaches have been counted in line at one time on the road, and large, broad-wheeled wagons, covered with white canvas laden with merchandise and drawn by six Conestoga horses were visible all day long at every point, and at many times until late in the evening, besides numerable caravans of horses, mules, cattle, hogs and sheep. It looked more like the leading avenue of a great city than a road through rural districts.

And then it was over.

By 1830, the B&O Railroad had reached Ellicott's Mills west of Baltimore. A year later it was in Frederick; four years later it was in Sandy Hook. On November 5, 1842, the first train steamed into Cumberland, and by 1853 it

Early in the 1900s, passenger trains put roads out of business, not the other way around. The B&O here parallels the Old National Road, which at the time was short on traffic and high on cracks. *Courtesy Allegany County Historical Society.*

had reached Wheeling. Keeping pace, sort of, was the Chesapeake and Ohio Canal, which itself was virtually outdated by the time it reached Cumberland in 1850. With such easy passage, the National Road was all but forgotten, "The canal and the railway have superceded the Old National Pike and it is not often now that a traveler disturbs the dust that lies upon it," wrote *Harper's.* "The dust itself indeed has settled and given root to the grass and shrubbery which in many places show how complete the decadence is."

Seeing the handwriting on the wall, some of the road's champions had argued against the extension of the B&O beyond Wheeling. Representative Henry Beeson of Pennsylvania went so far as to conduct an exhaustive economic study, totaling up the number of horseshoes and nails, bushels of grain for the taverns, tons of hay and other items that depended on the road, right down to the last egg that was delivered by way of the pike. It did no good, and towns that had boomed began to fold.

In 1879, *Harper's* wrote, "Hancock, which was one of the busiest villages on the road is now lugubriously apathetic and the citizens sit before their doors with their interest buried in the past. The main street is silent and the stables are vacant."

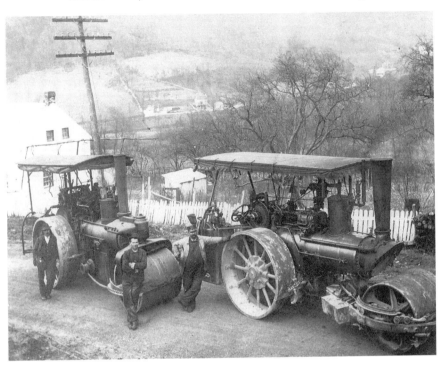

Although the National Road was the first to use macadam, it was still in frequent need of repairs that it didn't always receive. Here, rollers are shown atop South Mountain in a pass known as Turner's Gap. *Courtesy Doug Bast.*

Where taverns were once as common as mileposts, now none could be found between Hancock and Cumberland. Curiously, something similar was to happen a century later. With the arrival of the automobile, roads became fashionable again and a then modern U.S. 40, roughly following the old pike, brought travelers and commerce back to sleepy mountain communities. Then came the interstates, and once again the old roadway was forgotten. Up to modern times, travelers who cared to drive the twisting old route could see ruins of old motels and roadhouses that lived and died by the whims of modern transportation.

Still, the mountains themselves had, and have, lost nothing. The *Harper's* writer may have found little company on the road as the nineteenth century drew to a close, but "as the sun lowered, the exhalations of the pines became more pungent, the mountains looked lovelier than ever as the stars began to palpitate above the clear cut ridges."

But if the mountains were placid and still, the people who lived among them through the majority of that century were not.

Chapter 6

THE MOUNTAINS
GET TO WORK

George Washington was tooling around up on the Allegheny Front in 1755 when he stumbled upon what would be known as the George's Creek Coal Basin, the Maryland portion of a vein that runs eight hundred miles from Pennsylvania to Alabama. Flanked by Dans and Big Savage Mountains, the basin is five miles wide and twenty-one miles long. Fingering the black rock, Washington knew that he was holding the product that would fuel the colonies. And the amount of it seemed endless. There was also more than coal, as Washington reported:

> *This wonderful country impresses me more and more each time I go through it. These mighty forests of soft and hard wood will furnish the ships of the world, and with the native stones build the residences of future generations. There may be stored mineral wealth will astonish the countries of the Old World, while the fuel of the future may also be found therein.*

Indeed, Maryland coal would eventually feed fires in Britain, Brazil and Egypt, to name a few places. It powered the steamships of the U.S. Navy and provided an economic backbone for the region.

In 1755, however, in the middle of the wilderness, it was all but useless. They might as well have had a Dairy Queen on the moon.

In fact, it would be nearly a century from the time of Washington's discovery until the first load of coal was shipped to the coast. Seventy years after Washington's discovery, men were still gushing about the abundance of natural resources and were still puzzled how to make use of them. Hoping to attract investors, land speculators would hire assessors to evaluate their lands. They were always impressed; the region had seemingly unlimited supplies of timber, iron ore and coal. But at the end of the report they would

note the downer that, at the time, there was no way to bring these resources to market.

The Reverend John Grant, a Garrett County historian, said that early attempts to transport by way of the Potomac were only mildly successful. The early mountain industry of far Western Maryland was timber, which would be carted to Westernport on the Potomac, beyond which the waters were not navigable. There, timber and coal were piled onto flatboats and floated down the Potomac to Great Falls, where it was unloaded and the boats broken up for scrap. The boatmen then faced a lengthy walk back to Westernport to do it all again. There was some suspicion at the time that this might not be the most efficient form of transport.

Of course if you can't take the coal to the industry, you can always bring the industry to the coal, and in concert with this paradigm a host of diversified industries sprouted up in the mountains, from glass to textiles.

The first industries, however, depended on water power, in which Western Maryland was also rich. Down in the valleys, farmers were sowing corn and

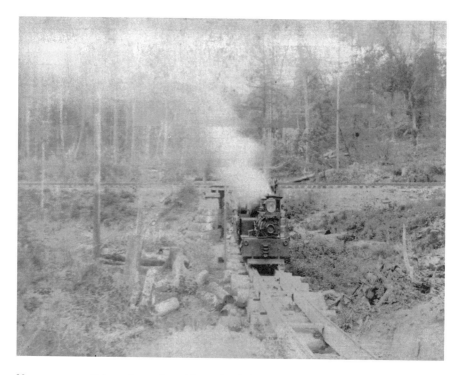

Narrow-gauge, dinky trains such as this one hauled timber—one of the earliest Western Maryland industries—out of the forest, where it was loaded onto standard rail cars or canalboats for shipment back east. *Courtesy Allegany County Historical Society.*

small grains, especially wheat. Although the early gristmills could hardly be called industry as such, these were probably the first mechanized, commercial enterprises. As settlements meandered west, one would usually pop up when enough of the sparse population grew tired of trekking ten miles just for a sack of flour.

Typically, they had but one buhrstone—imported from France, if possible, since the rock there was said to have better abrasive qualities—and one operator. Sometimes a sawmill would be attached, this enterprise also being necessary, or at least helpful, for building homes and barns.

The other early industry was alcoholic in nature. Again, the early stills were not large and served a small clientele. Professor Paul McDermott said that in Maryland, ciders and brandies might have pre-dated the more customary, corn-fed models. That's because in his land grants, Lord Baltimore required new landowners to plant one hundred fruit trees as part of the deal.

"He saw it as survival; you had to have the fruit—apples, peaches, cherries. So the colonial reality was that they were creating drink from the fruit and ciders and brandies may have come about before the whiskeys," McDermott said.

Western Maryland has a long tradition of orchards that began when the colony required settlers to plant one hundred fruit trees on their new land. Not all of that fruit wound up in desserts. *Courtesy Doug Bast.*

This may have even been the genesis of Johnny Appleseed, whose habit of planting apple trees in the Ohio territory was probably itself sown through the habits developed by his Maryland ancestors. To this day, orchards flank the sides of South Mountain, although the industry is a shadow of what it was as late as the twentieth century.

The stills in colonial America had no problem keeping up with the gristmills. Early on, if you had fired one batch of whiskey at every still in Washington County, it would have produced thirteen thousand gallons, or a gallon of hooch for every man, woman and child living in the county at the time.

Small stills and gristmills were for sustenance, however, not the mass market. Eventually, they would grow into larger mills and distilleries that would produce in quantity, but that generally occurred after 1800. Once survival was assured, however, commercial-minded pioneers began looking for ways to produce something that was acutely scarce in the settlements: cash.

In the mountains, that meant minerals, and on the eve of the Revolutionary War, iron was especially useful. In the mountains along what would be the Frederick-Washington county line, two important forges were gearing up for action.

Thomas Johnson, an outspoken patriot who placed George Washington's name in nomination for the colonies' commander in chief, had some mountain land, along with his brother, in the Catoctins and plans for an iron furnace. It was nearing completion by the time of the Declaration of Independence was signed. Two weeks later, anxious revolutionaries contacted Johnson, asking if he could supply cannons, shot and camp supplies. Johnson replied that the furnace was as yet incomplete and that he couldn't enter into any contract because he could not verify the quality of the metal.

Johnson was optimistic, however, about as optimistic as the colonial Council of Safety was desperate. If Johnson was worried about the forces that powder would put on gun barrels, he was more confident that he could produce pots and kettles for the army, since they were likely to endure significantly less stress.

All things being equal, though, the council felt that in the face of a charging army of Redcoats, cannons would be of more help than a soup pot.

In a Catoctin Park history, Edmund Wehrle writes that the council emphasized the need for artillery, asking for something in the neighborhood of one hundred big guns. "With the council's offer to purchase guns, the paper trail ends," Wehrle writes. So it is not a certainty that the Catoctin furnace was of assistance to the cause. However, "The Johnson works was a

new, centrally located furnace owned by a well-connected patriotic family. It would be difficult to believe that the Johnson enterprise did not contribute to the war effort."

Over the hill, on the west side of South Mountain, the Mount Aetna furnace, established in 1770, was indeed producing cannons—the first Maryland cannons supplied to the war effort—and here the quality was less in question, or so the story goes. Harold Ward of the Western Maryland Railway wrote in 1962 of an old cannon that was dug from the ruins of the old works for use in a Fourth of July celebration at Smithsburg. The old relic was exhumed in 1826, "where it lay for probably half a century," and cleaned up on the chance that it would shoot, or blow up, or do something interesting to add meaning to the festivities.

When it was fired for the first time—Ward did not mention how close the audience was willing to get—the gun held. This nonevent was greeted with some sense of disappointment, so an extra-large charge was poured into the weapon, and again it was none the worse for wear.

Never send a man to do a teenager's job, though. One winter a couple of boys decided that they would get the better of the cannon, so they poured water into the barrel and let it freeze. Then they packed a charge large enough to send a donkey over the mountain, lit a slow fuse and ran. The gun, Ward wrote, "rebounded fearfully, but on examination as found to be as firm as ever."

Ward wrote this story as a testament to the quality of the South Mountain ore, although it could just as easily have been a social study on how the mental makeup of teenage boys has not changed over the years.

By 1815, Mount Aetna had closed and ironworks were moving west. One important side note was the effect that the works—and early industry in general—had on the landscape. In the late 1700s, the forest was one of the mountain's great natural resources and, as far as the settlers could see, a resource without end. To fire their furnaces, ironworks depended on copious amounts of charcoal, made by smoldering logs in an earthen bunker. Sawmills and tanneries, which were sprouting up at the time, depended on the forests, but it was the ironworks that clear-cut incredible amounts of forestland.

At Mount Aetna alone, McDermott said that one square mile of forest, or four hundred acres per year, was cut to fire the furnaces. "They were tremendously consumptive of timber," he said. "The area adjacent [to the furnace] had to be completely devastated of forest."

Ore was even more plentiful to the west, but early on a new fuel came online—coal. By the 1820s, a furnace had been built near Friendsville, although it was short-lived. A more successful operation popped up in 1837

at Lonaconing, eight miles southwest of Frostburg, according to James H. Swank and James Moore Swank's *History of the Manufacture of Iron.*

The furnace was fifty feet high, and in a couple of years it was producing seventy tons of iron a week, using coke (a purified form of coal) as fuel. Several years later, in the town of Mount Savage, the Mount Savage Iron Company was also burning coke and became the first works in America to roll iron rail for the railroads. (Early rails were made of wood capped with an iron strap. Occasionally, the metal would snap under the weight of a train, and the strap would spring up through the floorboards of a passenger car like a switchblade through a sheet of paper; in some circles this was viewed as an inconvenience.)

"Allegheny County, Maryland, is thus entitled to two of the highest honors in connection with the American Iron trade," the Swanks wrote. "It built the first successful coke furnace and it rolled the first heavy iron rails."

By the 1880s, Western Maryland's glory days of iron production were waning. In twenty years, Maryland dropped from fifth to eleventh in pig iron production. The "endless" supplies of ore weren't endless after all.

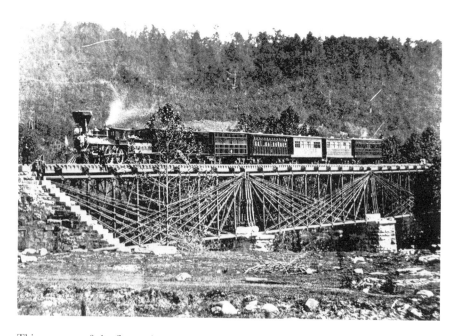

This was one of the first trains to cross the Alleghenies. As steam engines became more powerful, rail became the main transport for coal and iron. *Courtesy Garrett County Historical Society.*

More significant, however, was that in 1867, prospector Leonidas Merritt sunk his hammer into the ground in the northeast corner of Minnesota and discovered the great Mesabi Iron Range that by the end of the century had all but made the small eastern veins irrelevant.

By that time, however, iron in the mountains was becoming an afterthought. With the introduction of the railroad, it was turning out that the coal that had fired the iron furnaces was of greater value than the iron itself.

The railroad, along with the C&O Canal, was a game changer for mountain industry. Suddenly, landlocked resources could be whisked back east in great quantities. Both the railroad and the canal began construction in July 4, 1828, but from there their fortunes diverged. Initially, it was thought that there would be room for both—the canal hauling freight and the trains, passengers.

The canal has been maligned for its financial unsoundness (corporate bailouts are not new; the money Maryland pumped into the canal almost bankrupted the state) and the notion that by the time it arrived in Cumberland in 1850 it was already obsolete. But it cannot be considered a total failure.

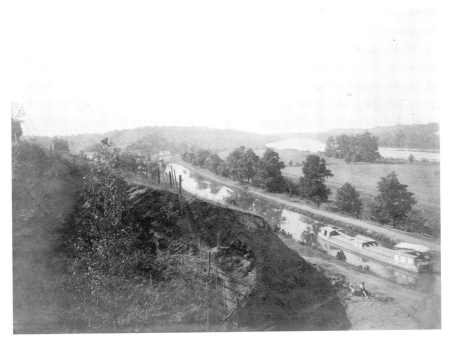

The C&O Canal was always in tenuous shape, plagued by poor finances and floods. But it survived well enough to haul millions of tons of cargo along the Potomac River. *Courtesy Ellen DiBiase and Lewis Mountcastle and the R.M. Hays Collection.*

At its zenith, in the early 1870s, it was responsible for transporting almost a million tons of goods a year, including coal, timber and flour.

Steam engines were growing more powerful, though, and they could branch off where the canal could not go and run in winter when the canal was frozen. The canal was also subjected to one calamity after another, the most serious of which were floods, which could shut down the route for a year or more. It limped along until 1924, when a major flood put it out of business for good.

In the grand scheme of things, heavy industry wasn't far behind. Like the settlers themselves, industry was moving west, to the Ohio River and beyond. The mountain mineral supplies that George Washington and others in colonial times believed could never be depleted were not gone entirely, but they were dwarfed by richer veins, where broad rivers allowed easy transport. The result in the mountains might best be seen in the example of Mount Savage, a community that a century ago looked to be going places.

But for a river, the town of Mount Savage might have become Pittsburgh. All signs were pointing in this direction in the nineteenth century, when a spectacular abundance of natural resources built the remote trading post into a throbbing hub of industry. A massive furnace melted ore into iron

The great flood of 1924, shown here at Cumberland, put the C&O Canal out of business for good. *Courtesy Allegany County Historical Society.*

ingots that were wheeled to the foundry, where they were rolled into workable sheets and shaped into the nation's first all-iron train track rails. Some of the heaviest locomotives of the age were hammered together at the rail shops.

The best clay for brick making in the entire world was dug from the hills, and the yards once employed 3,500 hundred people. These enterprises were fueled by coal, dug from Big Savage Mountain in amounts that supplied the town with plenty left over to ship to the cities.

A beautiful bank was built in 1902. A fine brick headquarters for the Union Mining Company opened its doors that year, and some of the town's best homes went up then, too. "Evidently it was a boom time for the community; 1902 is a pretty important year around here," said Mount Savage Historical Society president Dennis Lashley, who has spent considerable time digging, literally, into Mount Savage's past.

The town was feeling good about its chances at the turn of the century, so in 1902 it basically tore down and rebuilt. Town life must have been at once wonderful and terrible. Five tracks pierced the heart of the town, and steam locomotives shot thunderheads of black smoke into their air, which mingled with smoke pouring from a multitude of kilns, coke ovens and furnaces.

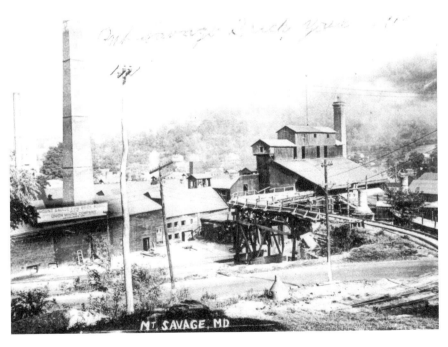

The town of Mount Savage, once a throbbing coal, iron and brick hub, is now a virtual museum of industrial age architecture. *Courtesy Allegany County Historical Society.*

The longest tram in the nation, at a mile and a half, brought clay down from the hills. The bricks built the New York City subway. They were of such high quality that the U.S. Navy specified that any bricks it purchased had to meet "Mount Savage standards." A Scot named Andrew Ramsay invented a one-step firing process to produce the distinct, cream-colored, glossy Ramsay enamel brick—he took his secret formula to his grave.

Trade boomed. Irish immigrants worked the mines, mills and yards, explaining, perhaps, why the town was able to support fifteen saloons and was required at the turn of the century to build its first jail, which was a drunk tank more than anything.

Hundreds, if not thousands, of men commuted to Mount Savage each day to work. Thirty-three locomotives were built in the shops, and work started on No. 34.

It was never finished.

About as suddenly as it had come, the flush times had gone. Some residents can remember the days when Mount Savage supported both an Acme and an A&P grocery. Today there's not even a convenience store. Or a gas pump. Three taverns have managed to stay afloat, though, so there's that.

Unlike Pittsburgh, Mount Savage didn't have a mighty river to ferry, by barge, mass quantities of raw materials or finished products in or out of town. For a time, it was hoped that the C&O Canal would reach Cumberland to facilitate shipping to eastern markets and ports. Way behind schedule, that section of the canal was eventually completed, but it was too little, too late. The Mount Savage iron industry was also damaged by a relaxation of the tariffs on British imports. Also, the foundry may not have been quick enough to understand the significance Henry Bessemer's invention in the 1850s of a process that would reduce the carbon content of pig iron and the importance of the resulting product: steel. With the end of the Civil War and its appetite for cannons and shot came the end of the ironworks.

Lashley, who has done just about any job imaginable—from gravedigger to repair of Washington, D.C.'s automated Metro subway system—sees a silver lining. Because no new wave of development came along, none of the old stuff was bulldozed to make way for the new. Much of the old works have crumbled, to be sure, but there are still ghostly glimmers of what was.

When the iron furnace opened in 1839, no one knew that it could flame out so fast or disappear so completely—almost.

In a tangle of mature trees and the equal of Br'er Rabbit's briar patch growing thick in a narrow hollow, Lashley became aware of something that even elderly followers of town history did not know existed. It was an outcrop of the massive furnace that melted Mount Savage ore. Lashley

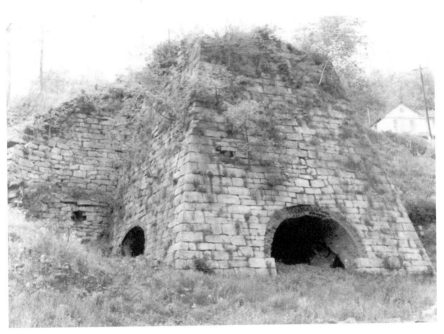

Iron furnaces such as this one at Lonaconing roared throughout the Maryland mountains until they were supplanted by vast iron fields to the west. *Courtesy Allegany County Historical Society.*

began to clear away 150 years of growth, helped by townsfolk who would occasionally drop by to pitch in. The result was discovery of a brick-lined (ironically, the brick at the time had to be imported from England—who knew?) stone furnace, including a cavernous room thirty feet high and fifty feet deep, where air was heated and blown into the blistering coke ovens that melted the ore. "This was the daddy of them all; there was nothing like this one" at the time, Lashley said.

The furnace has crumbled to perhaps half of its original dimensions but is still a considerable ruin, partly frozen in time, partly destroyed by it. It joins a number of other stone footprints of past industry, including a row of twenty-two foundations across the way that were once three-story duplexes for Irish workers. "Considering that these guys came from Ireland at the height of the potato famine, these had to be a luxury," Lashley said. One of the duplexes has survived, sort of—it was rebuilt out of the ruins of two others—and now serves as a museum for the town historical society. The narrow street still bears its original name—Old Row, appropriately enough. The town also has a New Row, Yellow Row and such, as well as Zig Zag Street, and it is safe to say that the town father was inspired when he named it.

Better preserved are the old First National Bank and Union Mining headquarters of 1902 fame. Indeed, the bank seems frozen in the early 1900s, with gorgeous and substantial mahogany counters and woodwork, the original safe and file cabinets, iron hardware and even the clerk's old typewriter. It served as an actual bank as recently as two decades ago, but despite changing hands a couple of times, the only changes the new banks bothered to make were to relaminate a couple of worn desktops. In these buildings, and even in the ruins, Lashley sees hope for his town. Instead of a rolling mill, coke oven or a rail shop, the town and historical society have a website—www.mountsavagehistoricalsociety.org. Gone are the industries of brick and coal, but Lashley—as do many throughout the mountains—hopes that the new industries of tourism and recreation will bring them back. "We are working hard to make this town a place where people might like to spend an afternoon," Lashley said.

Chapter 7

WAR AT THE SUMMIT

S andy Hook is a small community that clings to bluffs overlooking the Potomac River. It got its name, the local story has it, because of a soft, sandy spot in the wagon road. So many conveyances got bogged down in the sand that it became regular practice for the townsfolk to hook up a team of horses to pull them out of the soup.

On July 3, 1859, a rawboned man with wild eyes, a bathmat of a beard and a shock of hair straight out of the Don King school of coiffery stepped off a westbound train and looked around. His name, he said, was Isaac Smith—an entry of "A. Smith" in a Hagerstown hotel register is now considered one of Washington County's most precious artifacts.

Smith didn't attract much attention; he wanted it that way. Identifying himself as a cattleman from New York with an interest in prospecting in the southern part of the county, he began asking about the availability of a farmhouse where he could base his operations for a time. There was nothing unusual about the request.

Robert Kennedy had purchased a cottage on about two hundred acres of land in the hills of southern Washington County from the Antietam Ironworks in 1852. He had fixed up the cabin and lived there for seven years before his death. For Smith, it was a nice fit. It had plenty of land for farming and a plausible tie to surrounding minerals. He rented the empty cabin for thirty-five dollars, and soon thereafter heavy crates began arriving by wagon—mining tools, Smith told the neighbors.

But the crates didn't contain shovels; they contained guns and pikes. And Isaac Smith's name wasn't Isaac Smith; it was John Brown.

Today, in a world of mass media and *America's Most Wanted*, the distinctive-looking Brown wouldn't have had a chance (although he appears more neatly clipped in 1856 photographs). He was wanted in connection with

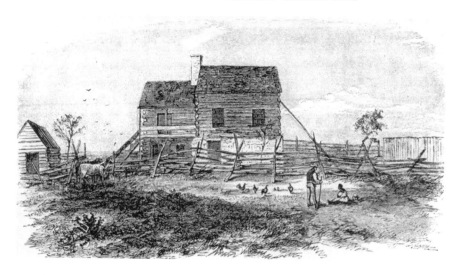

The Kennedy farmhouse, tucked in the hills of Washington County, served as a hideout and training ground for abolitionist John Brown's raiders. *Courtesy Captain South Lynn.*

bloody attacks in Kansas against slaveholders and had been hiding out deep in the Adirondack Mountains of upstate New York, near present-day Lake Placid.

Maryland was a long way from Kansas, though, and no one seems to have given Brown's presence a second thought. To bolster his "nobody here but us farmers" charade, Brown sent for his daughter and daughter-in-law, partly to cook and clean and partly to support his family farm cover story. Less featured were the men, white and black, who began to straggle in to the makeshift compound. (The Kennedy farm was purchased by Captain South Lynn in 1973, who beautifully restored the old farmhouse and calls it the best-kept historical secret in the state.)

If prospecting didn't raise any eyebrows, the sight of black and white men armed with muskets drilling in the backyard certainly would have, so they practiced by night and by day were secreted away in outbuildings and the farm's small attic. Their commitment to the cause can be assured by the fact that they were willing to be penned up in a small, stifling space through the dog days of summer.

Slaves were not uncommon in Western Maryland at the time, nor were free blacks. The farms, constrained in size by the mountains, did not lend themselves to the vast, labor-intensive plantations of the South. Many slaves were household servants, and those who worked the fields would often find the farm owner working alongside. In the Deep South, misbehaving

slaves were threatened with beatings. In Maryland, misbehaving slaves were threatened with being sent to the cotton fields of the Deep South.

The Pennsylvania line, and freedom, was but a few miles away. In Pennsylvania, the Quakers famously aided runaway slaves, but the lesser-known Dunkers and Mennonites of Maryland also had the slaves' backs. Rumors of Underground Railroad stops abound in the Maryland mountains, although given the inherent secrecy of these locations, their existence is frequently difficult to prove.

For slaves, Maryland was paradoxically as dangerous as it was relatively safe. Bounty hunters hung out at the state line like bears on a salmon run, snagging careless runaways who—given the geographic uncertainty of the time—might have believed that they were already in Pennsylvania. If runaways were scarce, these bounty hunters were not above snagging a free black and selling him south. This could touch off fireworks between slave hunters and slave protectors. In Emmitsburg, on the eastern flank of South Mountain, a respected free black was nabbed by bounty hunters, who were then themselves nabbed by outraged townsfolk, who rode them out of town on a rail.

Naturally, the mountains provided cover. A century before hikers traversed the crest of South Mountain for recreation on the Appalachian Trail, slaves scurried along the ridgeline for their freedom. Historian Dennis Frye believes that Brown's ultimate goal was a series of armed forts running north and south through the mountains, a pipeline of safe passage from the Deep South to the North.

More immediate to Brown's plan was the capture of the Federal arsenal at Harpers Ferry, and by October he was ready to engage Phase I of his plan. With nineteen followers, he marched to the Potomac on the night of October 16 and then followed the river downstream to the great cleft in the mountains at the confluence of the Potomac and Shenandoah Rivers. These narrow chasms, it was believed, would make the armory at Harpers Ferry easy to protect. Perhaps. It would have been easier, however, if the government had chosen to guard the guns with more than a single night watchman—which it didn't.

Ironically, Brown's attack was, for all intents and purposes, derailed by a free black man in the employ of the B&O as a baggage master. As he watched the armed band trudge across the bridge into town, he assumed what anyone would have at the time: train robbery. Hayward Shepherd had no way of knowing that this ragtag band was intent on ending slavery.

Shepherd ran up the tracks to warn an incoming eastbound train and was shot by Brown's troops. The shooting awakened a physician, who fruitlessly

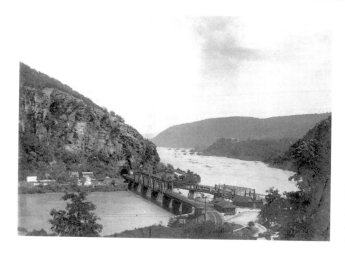

Harpers Ferry at the confluence of the Potomac and Shenandoah Rivers, where John Brown led his ill-fated raid that nevertheless planted the seeds of the Civil War. *Courtesy Ellen DiBiase, Lewis Mountcastle and the R.M. Hays Collection.*

attended to Shepherd before jumping on his horse and, according to Frye, making a heroic dash to alert a garrison in Charles Town, which was the Civil War equivalent to Paul Revere's midnight ride.

Brown was quickly caught and hanged, but his raid fueled a palpable paranoia in the South. Suddenly, no one could be trusted—your very neighbor could be posing as a farmer but in fact have plans to inspire a slave revolt. Nor was his action popular locally at the time. The Hagerstown *Torch and Light* at the time told of Harpers Ferry residents standing on the railroad bridge and taking potshots at the corpse of one of Brown's men floating in the Potomac.

Today, however, Brown is seen as a man deserving of commemoration if nothing else. Since the 1970s, a group of history buffs dressed in period garb have gathered at the Kennedy farm in mid-October and marched in the dark down out of the Maryland hills to Harpers Ferry. The narrow road along the river is paved, but otherwise it is much like the wagon path that Brown and his men followed 150 years ago. It's unpopulated and infrequently traveled. In the fall, a thick fog often hangs on the river.

On one commemorative march, Frye said that he and his group—in period dress and shouldering carbines—were silently hiking through the fog when headlights appeared ahead. As it passed, the band could see the markings of a county sheriff's cruiser. Determined to stay in the moment, they did not break ranks or otherwise acknowledge the deputy. The cruiser passed, but a couple of hundred yards down the road stopped and turned around.

Slowly it rolled up to the fog-shrouded "soldiers," who again kept their eyes to the fore, although they expected to be imminently confronted by

the law. Instead, the deputy pulled even and took one last disbelieving gape before flooring the accelerator and putting as much ground between himself and the ghostly specters as the laws of physics would allow.

After Brown's raid, three more years would pass before the mountains of Western Maryland once again played a crucial role in the great civil unrest.

General Robert E. Lee was consistently cooking up new experiments and trying them out on the Yankees to see how they would go. On August 30, 1862, the South emerged victorious from the Battle of Second Manassas, or as Northerners called it, the Second Battle of Bull Run. (The North and South couldn't agree on anything; the North named battles after nearby watercourses, the South after nearby towns. Being nondenominational, I will refer to this as the Second Battle of Bullnassas.)

Lee must have wearied of whipping the North multiple times on the same ground, so he promptly packed up his army and headed north to cross the Potomac—which he did on September 4, the first time that Lee had invaded Union soil. Although he stood in Maryland, he had his eye on Pennsylvania, where he hoped a victory over the Union *in* the Union might yield positive results. One matter had to be dealt with—a Union garrison at Harpers Ferry that could prove bothersome to a northern march. Harpers Ferry sat in a gorge more or less across the river from the southern terminus of South Mountain. So Lee divided his army, sending Stonewall Jackson to Harpers Ferry. He split off a few more segments to investigate rumors of Union troop movements; protect a supply train in Boonsboro; and guard against Yankee forces moving (or more accurately, fleeing) from Harpers Ferry into Maryland, which could also be a nuisance to his grand scheme. It was all rather much and all rather unheard of. For all we know, he may have split off another branch of his army to go out and fetch the newspaper.

With all in place, or in many places, Lee moved north, all going according to plan. But even the most cunning stratagem can fall victim to random carelessness—ask any bank robber who has ever lost his car keys.

By the wildest of chance, a Rebel whose name has been lost to history—and for the sake of his descendants, it is probably a fortunate thing—left behind a copy of "Special Order No. 191," which was a detailed blueprint of Lee's plan. By another wild chance (the Union was never terribly lucky in such matters), the plans were discovered, wrapped around a bundle of cigars, by a Yankee soldier.

The Union instantly knew the South's every move and every location and were free to operate under this information as it chose. With such an advantage, you would normally think to yourself, "Ballgame."

Sadly for the North, things were never quite that simple. Lee's army was stretched along a thin, tenuous line from Harpers Ferry up to Hagerstown, and it was highly vulnerable. All Union general George McClellan had to do was pierce Lee's line at the midpoint, and from there it would merely be a matter of mopping-up duty as he decimated Lee's fractured troops. With uncommon speed (for him), McClellan moved west from Frederick to the base of South Mountain.

More than a century prior, settlers coming to the New World had found themselves in much the same place. Times had changed, but the mountain had not. Like the early pioneers, the Army of the Potomac had to cross South Mountain to achieve its prize. So there it was: long and rather low in mountaineering terms, with three even-lower passes through which soldiers could flow with relative ease that went, north to south, by the names of Turner's, Fox's and Crampton's Gaps.

All three were guarded by Confederate forces of varying sizes on September 14, 1862, troops that had been posted on the off chance that the Union might advance. However, "advance" was a word that McClellan was not terribly familiar with, and consequently Lee believed a few thousand men sufficient to guard against this remote possibility. He didn't yet know that his plans had fallen into enemy hands.

The Union attacked all three gaps with—as the 1954 Supreme Court might have called it—all deliberate speed. In military terms it was slow, but for McClellan it was a lightning strike. Lee dryly noted that McClellan was "advancing more rapidly than was convenient." The fight was truly a house divided. Two brothers from Boonsboro fought on opposing sides during the battle of South Mountain before heading back into town to eat breakfast together. Three days later they fought against each other at Antietam.

From behind a stone wall on the eastern side of the mountain at Crampton's Gap to the south, five hundred Confederate soldiers watched on as twelve thousand Federals under Major General William Franklin began to deploy. With time of the essence, this might not have seemed the proper time to be fussy, but Franklin spent four precious hours getting things just right. A Confederate soldier mused that it was like watching a lion take all manner of precautions before pouncing on a mouse. One has to be careful when all you have in the face of five hundred enemy soldiers is a measly twelve thousand troops. Despite these unfavorable odds, Franklin was somehow able to prevail, but the time lost would be crucial. With an extra four hours, Franklin might have had time to plunge down into the valley and split the Confederate army. As it was, all he could do was order his soldiers to pitch their tents for the night.

Massacres, Moonshine and Mountaineering

Things weren't going as smoothly to the north. Fox's Gap proved deadly to Major General Jesse Reno of the Union and Brigadier General Samuel Garfield Jr. of the Confederacy. (Future president Rutherford B. Hayes was seriously wounded; another future president, William McKinley, was present but did not see action.) Southern defenders from North Carolina and some late-arriving reinforcements held on well enough to prevent a Union victory, and as night fell on the mountain, the pass still belonged to the South.

Much the same was happening in Turner's Gap, the cleft through which ran the National Road. There, General D.H. Hill, in his account of the battle, wrote that he got some assistance from an unlikely source—a mountain man who, sensing some rare excitement, was sitting out on the porch of his cabin to watch. One of Hill's majors was wearing a blue cloak that he had found at Seven Pines, and after asking the mountain man a few questions, it became apparent that he believed his visitors to be Federals—so he felt free to talk at length about the Union position. In the middle of the interview, a shell whizzed by. One of the children began to cry, and Hill offered the tot comfort before scurrying off to the battle. The Confederates were driven up the east side of the mountain but, aided by the rough terrain, made a successful stand at the top. Here, too, the South held the gap at nightfall.

That was about all that Lee could ask for, and he ordered his exhausted troops down off the mountain. He seemed prepared to accept defeat, but McClellan saved the day for the South by piddling around all day on September 15 without engaging in anything that might be confused with an attack. That wouldn't occur for two more days.

Hill noted that if the Union had put its full force behind the attack early on it could have all but breezed through the passes and caused mayhem for the South. Yet it held back, and Hill believed that it was because the "Lost Order" gave the impression that the powerful Longstreet was at Boonsboro and not Harpers Ferry.

> It was [incomprehensible to the] *losing side that the men who charged us so boldly and repulsed our attacks so successfully should let slip the fruits of victory and fall back as though defeated. The prisoners taken were from my division, but the victors seemed to think that Longstreet's men lay hidden somewhere in the depths of those mysterious forests. Thus it was that a thin line of men extending for miles along the crest of the mountain could afford protection for so many hours to Lee's trains and artillery and could delay the Federal advance until Longstreet's command did come up, and, joining with mine, saved the two wings of the army from being cut in two. But for the mistake about the position of our forces, McClellan could have captured Lee's*

The Old National Pike where it crossed the Antietam Creek, which gave the Battle of Antietam its name. *Courtesy Ellen DiBiase and Lewis Mountcastle and the R.M. Hays Collection.*

trains and artillery and interposed between Jackson and Longstreet before noon on that 14th of September. The losing of the dispatch was the saving of Lee's army.

The Battle of South Mountain occurred on a Sunday. A few miles to the west, a congregation of peace-loving Dunkers met in their small church for Sunday services. In the distance, they could hear the guns roaring on South Mountain. Relieved, they offered thanks that the armies had chosen the mountain for their fight, a safe distance from their small white sanctuary. They couldn't know that Dunker Church sat squarely in the middle of what was about to become the Antietam battleground.

Given new life, Lee scrambled south from Hagerstown with the main force of his army to stop the bleeding. Seeking any high ground he could find in preparation for a fight, history professor Tom Clemens said that Lee first settled on the heights just south of a small trout stream called Beaver Creek, ground that is today pierced by Alternate Route 40 just above the intersection with Benevola Church Road. Had the Union moved any faster, the great Battle of Antietam/Battle of Sharpsburg—the bloodiest single day of the Civil War—might have been known as the Battle of Beaver Creek/Battle of Boonsboro—or better, the Battle of Benevola, which is an

Old World word that basically means, "We welcome you and shower you with blessings." That would have been rich.

However, the Union was moving as slowly as it ever did, and Lee spotted better ground. That better ground was his old friend South Mountain. He ordered his troops to its high flanks, taking advantage of the fact that one soldier on high ground is worth two soldiers on low ground. "Because he can use this effect there, that's why the battle was held [at Antietam]," Clemens said.

There, with the mountain at his side, Lee…well, he lost. Or he may not have lost, but he sure came as close to it as he had in all the campaign up to that point, and it allowed the North to claim the high ground of propaganda. Lee crossed the Potomac back into Virginia, his Maryland campaign having ended. France and Britain—those frontrunners—were discouraged from supporting the South, and Abraham Lincoln issued his Emancipation Proclamation.

South Mountain had held up Federal troops when otherwise they might have run roughshod over Lee's army. It allowed Lee a fighting chance once the battle was joined. What effect did South Mountain have on the Civil War? "Without South Mountain it's likely there would have been no Battle of Antietam," Clemens said.

Without South Mountain, the Federals would have had a free run through the middle of Lee's forces and the Civil War might have ended then and there. As it was, the terrain dictated the outcome, and the Confederates lived on to fight for three more years. So perhaps the name is proper. It is, after all, "South" Mountain.

A TALE OF TWO MONUMENTS

High on South Mountain overlooking the town of Boonsboro in September 1862 was an odd, man-made pile of rocks, shaped remarkably like the conical rifle balls used by Civil War infantry. On September 17, 1862, soldiers were said to report a curious sight—private citizens up at the top of the unusual structure, jostling for a better view of the raging battle below. The soldiers needed the high landmark for a signal post, so the public was dispersed. There's a good chance that this story is, technically, not true. At least there's no solid verification of it. But if it is, the original Washington monument above Boonsboro may have been the nation's first skybox.

Boonsboro museum curator and historian Doug Bast said that he hadn't heard such a tale, although it was common for local townsfolk to find a high point from which to watch the brutal festivities down below. Residents did gather on a hill near Boonsboro where a nursing home now stands, Bast said. They lost interest in the recreation when a wayward shell exploded at the base of the knoll.

Boonsboro's monument was the first completed masonry tribute to the first president of the United States. The mission arose out of a July 4, 1827 celebration in the town, where most of the town's five hundred residents met at 7:00 a.m., headed up the mountain and transformed their patriotic emotions into a great work of stone. Kind of a communal thing, it was written that "as monuments go, none was ever built with purer or more reverent patriotism." Working without mortar, they carefully cut and placed the stones and were able to build the monument to a height of fifteen feet by late afternoon, when it was decided that they would rest their case on what they'd done and come back and finish the job after the harvest season. They dedicated the monument with a reading of the Declaration of Independence

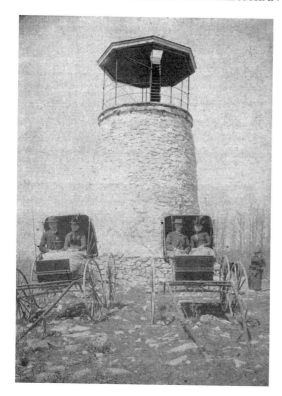

The Washington monument, after it was repaired by the Odd Fellows Lodge. The viewing canopy was not authentic and has since been removed. *Courtesy Doug Bast.*

and a three-gun salute from veterans of the Revolutionary War. By fall, the monument was indeed completed as promised, rising to thirty-four feet.

The monument site was used for a time as a setting for meetings, but as interest waned the stones began to fall, and by 1882 it more resembled a pile of rubble than a sacred tribute. It was rebuilt, again without mortar, at that time by the Odd Fellows Lodge of Boonsboro, which also cut a road to the site to improve access. Madeline Vinton Dahlgren, owner of the nearby South Mountain House in Turner's Gap, sprung for an elegant canopy atop the stonework.

Again, though, the monument began to weather, and not to its advantage. It developed a large crack that went unrepaired, and nature began to do its work. It had help. Vandals had always been a problem, and some did more damage than others. Apparently, "meeting place" was a broad umbrella that covered a lot of activities not limited to the nonromantic variety. A father got wind that his daughter was meeting a boy at the monument for—well, for whatever, and he decided to put a stop to it by lobbing a stick of dynamite into the stonework. This was viewed as a poor way to pay tribute to Washington, and by 1920 plans were underway to ensure that it

wouldn't happen again. At that time, the Washington County Historical Society purchased the property and deeded it to the state in 1934 to be used as a park. The monument was rebuilt, with mortar, by the Civilian Conservation Corps. With its commanding, 360-degree views, it is today a popular picnic spot and a curiosity for hikers on the Appalachian Trail, which runs through the property.

While it may be the oldest stone tribute on the mountain, it is by no means the strangest—not even close.

George Alfred Townsend covered the Civil War as a reporter and made a name for himself writing books. Verily, he was from another time, a quaint time when one could enjoy the honest pleasures of a good barn raising or make money in publishing—although Townsend groused that there was more money in newspapers than books and even seemed a bit self-effacing of his work, which he justified by quipping that he would rather write a tolerable book today than wait for the possibility of writing a great book in the afterlife. In the end, he decided that his chances for lasting fame were better in stone than stories, an attitude he characterized with the verse:

The Washington monument twice crumbled to pieces, the result of natural and unnatural causes. *Courtesy Doug Bast.*

In this Mathew Brady photograph taken shortly after the Civil War, George Alfred Townsend, left, is shown visiting with Mark Twain and Joseph McCullagh. *Courtesy Doug Bast.*

The bookman's art is left behind
And letters only vex.
Write then in stone ye minds of men!
And live as architects!

Literarily and historically speaking, Townsend is better known as Gath, a somewhat incongruous hybrid of his initials to which he added an *H* while under the influence of 2 Samuel 1:20, which says, "Tell it not to Gath, publish it not in the streets of Askalon." To Townsend, there was some kind of cosmic relationship between his name and Gath the publisher, or perhaps—oh never mind. It made sense to him in the way that tail fins made sense to 1950s car designers.

Townsend—whom biographers charitably (it would seem) describe as "unusual"—was born in 1841, and a scant twenty years later he was covering the major battles of the Civil War. He would have been clearly aware of South Mountain and, in particular, the significance of Crampton's Gap. Using the riches that he had obtained from a successful writing career, he purchased a tract of land on the east side of South Mountain and developed a compound called Gathland, which can best be described as a little of this and a little of that. One other advantage of his locale was a small parcel of land at which four roads came together in the gap at the mountain's crest. Owning that, Townsend was able to collect tolls from people traveling from all points of the compass—a fact that profited him in cash but cost him some in terms of popularity.

His mind never resting, Townsend would build something and modify it any number of times for a new use. A stable might become servants' quarters, which might then become a house.

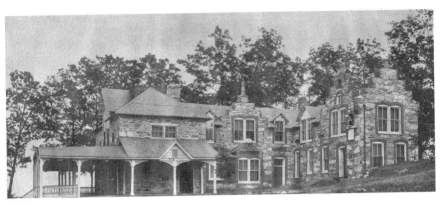

George Alfred Townsend built more than twenty buildings on his mountaintop estate. This one, known as the Hall, was filled with curiosities, although Townsend was frequently transforming his buildings for other uses. *Courtesy Doug Bast.*

By far, however, Townsend's most significant contribution to monumental memorabilia is the War Correspondents Arch dedicated to the journalists who covered the Civil War. Built in 1896, it is fairly safe to say that no other monument in all the land looks like the Correspondents Arch—or wants to, for that matter. Tourists who visit the monument invariably have the same question, which runs along the lines of "What was Townsend smoking when he designed *that?*"

It's not that it's ugly; it's just weird.

It might be described as a cross-section cutaway of a Roman aqueduct with a feudal castle turret nailed to the side, except that the lower arch (there is one large arch below, three smaller arches above) is Moorish and the entire production is littered with Greek gods. Why Townsend, while he was at it, didn't go ahead and toss in a couple of Russian Orthodox onion domes is anyone's guess. We do know that Townsend patterned the Roman arches after the architecture of the Antietam Fire Company in Hagerstown. He sketched the building's façade while sitting on a train in the city's rail depot, where the *Herald-Mail* newspaper offices stand today. Elsewhere on the arch, a zinc statue of the legendary Greek figure Orpheus is ensconced in the castle turret, which is fair enough, except that he's holding Pan's flute and wearing Mercury's helmet. For good measure, he's drawing a sword, probably as a defense against high school bullies who might be tempted to beat up such an oddball. At a rededication ceremony in 1996, Antietam National Battlefield superintendent John Howard tossed his hat in the ring for consideration

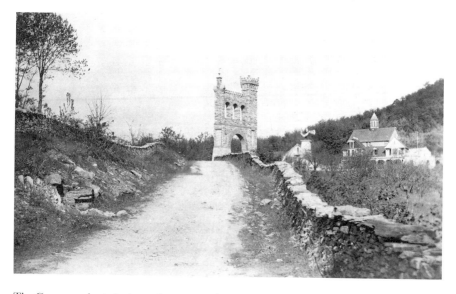

The Correspondents Arch, a tribute to wartime press, is a mishmash of architectural styles, random sayings and statuary. *Courtesy Doug Bast.*

in the world's greatest understatement competition by noting that the arch "kind of stands out."

The general public will be gratified to know that the monument was not funded with taxpayer dollars. Instead, Townsend raised the necessary $5,000 from an impressive array of donors, including J.P. Morgan, Joseph Pulitzer and Thomas Edison. It's not known whether they saw the blueprints before they wrote their checks.

Given all this, however, it could have been worse. The arch now serves as a monument to journalists of all wars, and in the '60s a state press association got the idea that the grounds could be improved upon by fashioning it into a sort of journalistic hall of fame, with an exhibit hall and amphitheatre. The crown jewel was to be an Epcot Center–esque globe of the world, where nations that had a free press would be lightly hued, while the rest of the nations were dark. The globe was to be ringed with a ziggy-roofed exhibit hall that—there is no other way to put it—much resembled a clown's collar. It is almost a pity that the plan fizzled and this building was never built. Next to it, the Correspondents Arch would have looked like the Sistine Chapel.

These two particular monuments of solid stone have made a lasting impression, but just as memorable among residents of a few mountain hollows are some airier spectacles.

THE GHOSTS OF THE GAP

E very old house, settlement and battlefield has its share of ghosts. It's sort of an unwritten law. When house-settlement-battlefield come together in one great supernatural convergence, though, as they do on South Mountain, it becomes something of a Grand Central Station of spooks—so crowded that a spirit hardly has the elbow room to give his chains a good rattle.

A great Civil War battle was fought in the narrow mountain pass above Boonsboro known as Turner's Gap, which is also the site of a venerable old tavern that traces its roots back to as early as 1732. It's thought that George Washington may have slept there—although, truth be told, the general is rumored to have slept in so many places throughout the region that it is amazing he was awake long enough to win the war. The inn, though, was indeed visited by presidents and statesmen, especially during the heyday of the National Road, which passed through the inn's front yard.

The road wound down along a stream through a chasm to the west, and here was the settlement of Zittlestown, a collection of cabins buried in the dark forest where the long shadows incubated tall tales that have been handed down to this day.

The inn was purchased in 1876 by Madeleine Vinton Dahlgren, a woman of letters and the widow of Rear Admiral John Dahlgren, who commanded the blockade of the Southern states during the Civil War and is considered a father of American naval ordnance.

Up to that point, the inn already had logged a rather impressive history in the annals of the young nation. Originally a stage stop, it had also been briefly commandeered by John Brown's followers (or visited by them—accounts vary) about the time of his raid of Harpers Ferry and was headquarters for Confederate major general Daniel Hill during the Battle of South Mountain.

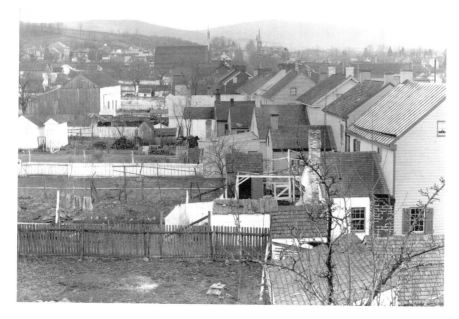

The backyards of Boonsboro, looking east toward Turner's Gap, home of an overabundance of spooks. *Courtesy Doug Bast.*

Madeleine Dahlgren turned the inn, which today is a posh restaurant, into a private residence and, among other things, began collecting ghost stories, which she published under the title, *South Mountain Magic*.

It should be mentioned that Dahlgren was a remarkable individual in her own right, with many titles to her credit, and trafficking in spirits was only one tip of a substantial iceberg of accomplishments. A devout Catholic—she had a stone chapel built across the road from the inn, which stands to this day—her take on the afterlife can best be described as conflicted. Some stories she seems to buy into, relying on the reputation of the witness. Others she rather scoffs at, mentioning that she's merely passing the story on for what it's worth and that her retelling is not to be considered an endorsement.

She tended not to be a fan of the Zittles of Zittlestown:

> *Here vegetate scores of souls, Zittles, married to Zittles, related to Zittles, or connected with Zittles. Amid these humble homes and in other similar huts farther down the slopes, or in the ravines that intersect them—some of these cabins almost buried in forest depths, as well as others perched on the cliffs beyond—ignorance, tainted by belief in magic, has taken the unearthly form of superstition…What has taken place goes to disprove any theory of evolution, for the reverse law has held.*

Before we indict the poor Zittles, however, it probably ought to be pointed out that in the 1800s belief in the supernatural was pretty much the rule, not the exception. Dahlgren herself seemed more inclined to buy stock in the ghosts reported to her by her own guests, or other unimpeachable sources—or maybe she was just a bit more discrete when it came to tagging friends and family as examples of devolution to their faces.

Dahlgren seemed amazed at the malleability of the Zittles' belief systems and the extent to which creeping Zittleism permeated the community.

As evidence, she pointed to the apparition known only as the White Woman, a friendly enough spirit against which the only knock—and it was a big one—was that, within weeks after a visit from the White Woman, some member of the kinfolk would expire. It was clockwork—White Woman, dead relative. Dahlgren's point was that a half-wit boy reported seeing the specter and everyone believed him. "We mention this story to show how strong is the general belief in this phantom when his recital is noticed and credited," she wrote. "Indeed, at times it requires very little to frighten people who are disposed to be credulous."

Although this is not to say that said disposal could not be useful. One woman, miffed that some young local hooligans were keeping her up at night, put an end to the shenanigans by wrapping herself in a white cloak and strolling aimlessly past the troop. The boys suddenly remembered some business they had to attend on the other side of town, Dahlgren wrote, and "a subdued quiet reigned that night in Zittlestown."

One of the first legends to gain credence among the locals was the story of a troop of soldiers, on its way south to fight the Seminoles, that stopped at the South Mountain Inn for a night. Long story short, one of the recruits falls in love with a member of the inn's staff, who encourages him to run off into the woods, where she will join him later, signaling with the wild cry of the panther. The stunt works, and the two live happily ever after. Right here, it would seem that we have rather infertile ground for a ghost story. The blood-chilling conclusion is that after the happy couple passed on, travelers on the National Road could still see the soldier's campfire at night down in the ravine and still hear the girl's pantherlike cry. Some even reported seeing a uniformed soldier poking at his fire in order to signal his well-being to his new love.

Dahlgren reported other strange events at the old inn that took place under her watch: spirits rattling a door in an attempt to contact a guest; a brightly lit apparition that didn't seem to have much of an agenda beyond glowing and worrying the visitors; and a pair of phosphorous wings that flapped and disappeared, mission unknown.

Sometimes these were a bit more complex, if only slightly. Just beneath the South Mountain House, a farmer was in a dispute with a neighbor over the boundary line between the two. Cleverly, or so he thought at the time, the farmer snuck out one night and moved the stone boundary marker, effectively increasing his holdings more to his satisfaction. He then called for a survey, confident that his case would hold up in court based on the misplaced marker.

Then he inconveniently dropped dead. His ghost appeared to his son, presumably to explain the plan and give further instructions. But it was poor judgment, because the terrified son, seeing the ghost of his father, dropped dead as well.

Lacking closure in the matter, the headless (why headless no one bothered to say) spirit haunted the National Road, burdened by chains and carrying the boundary marker, which glowed an incriminating crimson. "Where shall I put it?" he would call to passersby, who understandably averted their eyes and hurried on their way. This continued for some years until the ghost encountered a drunk who, knowing the story, beat the spirit to the punch and gaily howled "Where shall I put it!?" The dead farmer (though lacking a head, he seemed not to be wanting for a mouth) said something to the effect that this was exactly his point: "Where *shall* I put it?" The drunk said the question was rather obvious really: he should just put it back in its original position.

For whatever reason, such a simple solution had not occurred to this tortured soul, but it made sense. So he hustled back to the original boundary line and replaced the stone, which immediately lost its red glow and got back to the business of being a cornerstone. After that, the ghost farmer was never seen again.

That one was good, but not great. In our twenty-first-century society, when we are daily assaulted by some new and ever-gorier horror picture, these stories may fall a bit flat, but in their day they were probably stirring enough. Even so, just as these tales begin to get sluggish and lose their effectiveness on a modern reader, along came the Civil War, which livened things up considerably.

It may be that the most culturally popular story is the legend of Spook Hill. Outside Burkittsville on the eastern side of South Mountain is a rural road that appears to be a rather obvious uphill grade. Yet place your vehicle in neutral, and the car will slowly start to ascend the grade—the story is that you are being pushed by the ghosts of Union soldiers, much as they pushed their artillery into position during the Battle of South Mountain. I mention that this is a culturally popular site because more than one teenage

boy has been known to take a date to Spook Hill—terrified girls being more accepting of a comforting hug, as a rule.

It almost goes without saying that there are more Civil War ghost stories than you can shake a bugle at. Two South Mountain guests were said to be awakened by a strong smell of sulfur. On parting the curtains, they noticed smoke wafting up from the valley and assumed a nearby barn to be on fire. A servant was sent to investigate but saw nothing—and he was not terribly amused to be awakened in the middle of the night for nothing. Puzzled, the guests continued to watch the smoke until it coalesced into two armies reenacting their desperate fight for the mountain pass.

Similar stories have been repeated through the years, even by relatively modern-day hikers on the Appalachian Trail that makes its way along the mountain's crest.

One of the more enduring tales on South Mountain is that of the Black Dog, or, as it is more colorfully known, the "Snarly Yow." Stephen Brown, in his book *Haunted Houses of Harpers Ferry*, writes that sightings of this beast have been reported as late as 1975. The animal never hurts anyone (which doesn't seem very yowlike to me), but it certainly seems to have startled more than its share.

"What is quite remarkable regarding this delusion, if such it is, is that the specter of the Dog-Fiend has appeared to so many people, who aver to have seen it," Dahlgren wrote.

The dog is usually seen in the same place—near a stream along the National Road close to the small, pleasant estate of Glendale. One of the first reported sightings was by an earnest and honest mountaineer who lived with his family in a hut above Glendale. He had run to Boonsboro on a dark but starry night, and on his return was confronted by the aforementioned S.Y. The creature bared its fangs and refused to budge, so the mountaineer decided to "fit him." His words. I assume he meant "fight."

The man rolled up his sleeves and waded in. "But to his confusion, as the creature was attacked it 'grew longer,'" Dahlgren wrote, and presently it seemed to extend across the road, making no noise but showing a very wide and ugly-looking red mouth. All the while the thick and heavy blows rained down upon it, the sinewy arm of the woodsman met with no resistance but rather seemed to beat the air.

The shadowy hound eventually grew bored and moved on, leaving the man to return home, none the worse for wear from his encounter.

Plenty of tales are similar. Frightened folk would chuck a piece of ordnance at the beast, only to see the projectile go straight through the dog. One preacher encountered the yow three times, although Dahlgren notes

The stream and a footbridge leading to a spring that was home of a canine specter known as the Snarly Yow. *Courtesy Doug Bast.*

that "we are not informed whether the myth was pummeled with orthodox blows or dismissed with an Avaunt Satan."

South Mountain was to have one more bout of ghostly fame when Burkittsville, a charming, quiet village on the east side of the mountain, was named as the setting for the 1999 film *The Blair Witch Project.* The story was that in 1994 three film students disappeared in the woods outside of Burkittsville while shooting a documentary. A year later their footage was found.

This was not exactly the kind of publicity that Burkittsville was looking for, and its town fathers shouted from the hilltops that there was no such thing as the Blair Witch, there had never been any such thing as the Blair Witch and that the film wasn't shot locally, anyway. It did no good. Witch hunters came out of the woodwork and descended on the poor town, which did not see this as the best way of preserving its dignity. It is instructive to note, though, that the age in which people put their faith in spooks is not entirely dead.

On Boonsboro's main street, Doug Bast runs a fascinating and eclectic museum that flies beneath the radar of tourists and locals alike. Its artifacts

span the world from Boonsboro to Thailand and reaches back through the eons to include, among other things, a petrified dinosaur egg. At its core, the museum boasts an impressive array of Civil War documents and hardware. Bast has an eye for the quirky. Here are bullets that bored soldiers carved into a moustache comb, goblets, a dunce cap, dice and—why not—a woman's breast.

There's the largest cannon ball ever made for the Civil War (fifteen inches in diameter and 428 pounds); bullets from battles where the action was so hot that two projectiles would hit in mid air and weld together; and a letter from Henry Kyd Douglas to his father written on Union stationery. Before posting the letter, the author of *I Rode with Stonewall* took the time to mark a big X through the Union logo at the top of the page. At a modern-day dinner, Bast rescued Douglas's hunting knife from an ancestor who was using it to carve the turkey.

In the days following the battle, artifacts were plentiful. Farmers would gather them up, make them into monuments and sell them to visiting veterans. For years, there was nothing unusual about seeing a hog running along with the bone of a soldier in its mouth.

This was part of the fascination with spirits and the occult. It was an attempt to make sense out of things that otherwise didn't. Bast has a collection of Dahlgren's papers, as well as those from faith healer Michael Zittle, who in 1845 published a book listing the fifteen most important charms you could own—much in the way *Men's Health* today might list a fellow's fifteen most important grooming aids.

Answers were found in strange places. If a woman were sick, one familiar with the craft would remove her shoe and rub some fat on the sole of her foot. This fat was then fed to a pig. If the pig ate it she would recover; if it turned away, she would not. Given a pig's taste for fat, presumably few of these practitioners were ever the bearer of bad news.

Armed with significantly less hard, scientific knowledge, the mysterious and the paranormal stepped in to fill the void. A death was explainable if you could pin it on a White Woman, and these stories, Bast said, "were the way that they explained the world."

As the century waned, however, enlightened thought began to prevail. The industrial age was at hand, and along with science, new inventions and hard work came the need for an escape, preferably one where cool breezes and good times were there for the taking. The era of great mountain resorts was at hand, and none exemplified the breed better than an immensely popular mountaintop amusement park known as PenMar.

THE INDUSTRIAL REVOLUTION TAKES A BREAK

In the middle of the nineteenth century, the Western Maryland Railway was laying track northwest out of Baltimore toward Westminster, the goal being to reach the fertile valleys to the west. "It cannot be possible that the citizens of Western Maryland will long submit to being compelled to transmit their vast produce to a market double the distance to [Baltimore] and consequently at greater cost," Colonel John Mifflin Hood wrote in a report to his shareholders. There was also the thought that South Mountain might hold valuable deposits of copper and iron.

The railroad was champing at the bit to extend its line to Hagerstown, but there was this nagging feeling that the timing might not be exactly right.

The year was 1863.

The local landscape had been shot to bits, and bloodied Confederates were limping south down the Blue Ridge following their defeat at Gettysburg. The Civil War was a bad time to engage the community in a new building project, "when the minds of the people were intensely excited by the occurrences happening in their midst, and when the whole country was devastated by the ravages of war," Hood wrote. Today's tone-deaf CEOs might have proceeded at speed, but 150 years ago they apparently had better sense.

Construction resumed after the war, and by 1872 the line had reached Hagerstown and included an expensive piece of engineering that took it up and over South Mountain at the Maryland and Pennsylvania line. Atop the mountain's crest, Hood noticed a couple of things. One was the stunning view that incorporated twenty-two counties and four states; the other was a fresh, cool mountain breeze that seemed to always blow. The hoped-for copper and iron might never pan out, but it didn't matter—Hood had discovered vacation gold.

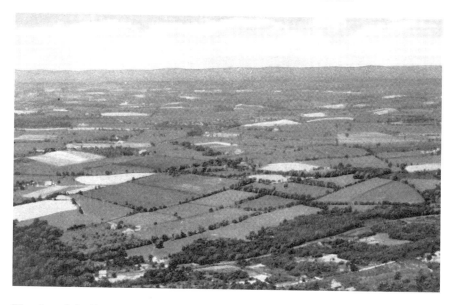

The view of the Cumberland Valley from High Rock at the PenMar amusement park. *Courtesy* Maryland Cracker Barrel.

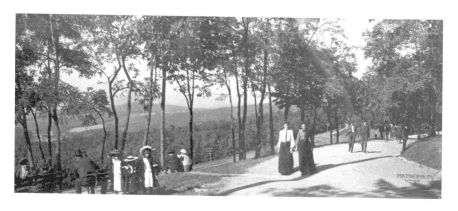

The promenade from the rail station up to PenMar Park, with a view of the Pennsylvania mountains to the north. *Courtesy* Maryland Cracker Barrel.

"It is difficult to overestimate the advantages to the [rail]road and the citizens of Baltimore that would result from the establishment of one or more first-class hotels on the summit of the Blue Ridge, only 71 miles distant," Hood wrote to shareholders. "There can be no question as to the success of such an enterprise."

To understand the success of what would become the PenMar park and resort community, it's helpful to understand the summertime misery of the

cities on the eastern seaboard in the days before air conditioning. They were dirty, hot and muggy, a virtual sauna of stagnant air. The Industrial Revolution provided the wealth that would allow sweating city dwellers a chance for relief, if such an opportunity presented itself.

The top of South Mountain provided that opportunity.

Five years after the railroad reached Hagerstown, the Western Maryland company chummed the waters by building a spectacular amusement park complete with a roller coaster, hand-cranked movie theatre, dance pavilion, a miniature train, carrousel (its ponies hand-carved in Germany), penny arcade, shooting gallery and dining hall.

Two magnificent, multileveled viewing platforms—one at the peak known as Mount Quirauk and the other at a rock outcropping high above the valley floor (creatively known as "High Rock")—allowed five hundred people at a time to take in the scene, which stretched from Pennsylvania to Virginia.

Almost instantly, people up and down the East Coast took the bait. Hotels and boardinghouses began to spring up to handle the crowds. In 1883, the Blue Ridge Hotel Company finalized plans for a grand hotel made of fine Georgia pine that would accommodate four hundred guests. The sense of urgency in providing expanded accommodations was reflected in the fact that the rambling Blue Ridge was built in two and a half months flat.

The dining hall at PenMar. *Courtesy* Maryland Cracker Barrel.

People poured in, and so did the superlatives. PenMar was "the Coney Island of the Blue Ridge," and the Blue Ridge was "the Alps of America." In a promotional brochure for the grand Buena Vista Spring Hotel, General Bradley Johnson gushed, "Having viewed the great unsalted seas of the Northwest—having seen the snow clad Rockies and the swift, deep current of the Columbia, and having been awe-struck at the grand magnificence of Mount Hood—I assert that I have nowhere seen a view comparable for mountain and plain with that from the Buena Vista Spring Hotel."

It was all a bit much, really. Mount Hood? Come now. But no matter; the public bought in. Rail platforms were jammed, and lines to board the Blue Ridge Express out of Baltimore extended for blocks—to the point that the railroad had to resort to assigned seating to make some order out of chaos.

The turnout blew away Hood's (the man, not the mountain) wildest expectations. According to a 1962 paper written by Harold Ward, Western Maryland Railway carried 1.2 million passengers in 1891, and 554,000 of those were headed to the mountain. Incredibly, the road made almost as much money hauling people that year as it did hauling freight. In all, seven hotels and one hundred Victorian boardinghouses sprouted up to handle the crowds.

From President Grover Cleveland on down, anyone who was anyone showed up at PenMar. A Baltimore columnist wrote, "If you were a young

Even though guests would park at PenMar for the entire summer, people reported that there was plenty to do without fear of boredom. *Courtesy* Maryland Cracker Barrel.

millionaire or wished to make an impression on your best girl, you could take her to the Blue Mountain House, where dinner was $1 (outrageous, but worth it), or [to] the Buena Vista Spring Hotel, where there were more servants than guests."

Orchestra music drifted nightly through the verandas of these palatial hotels, and guests could occupy themselves playing tennis, hiking, swimming or riding horses.

The Buena Vista boasted its own nine-hole golf course, six holes being on one side of the road and three on the other. The hotel eventually closed down the three after questioning the wisdom of having golfers twice be called upon to hit their balls over the main drag. Sadly, no stories exist as to which important personage may have been plugged in the melon with a wayward golf ball to require such a drastic change in policy. Maintained, though, was the stunning fifth tee, which offered an unobstructed view of the valley, covering sixty miles. A herd of sheep was employed to keep the links trim. Twenty men pushing reel mowers replaced the sheep, The men

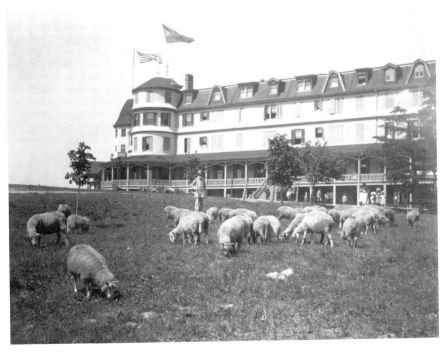

Sheep kept the golf course trim at the Buena Vista Spring Hotel until they were replaced by men, who were then replaced by a horse-drawn mower. *Courtesy Virginia Bruneske and Maryland Cracker Barrel.*

kept their jobs until the 1930s, when their jobs were outsourced to a mower-pulling horse. True story.

PenMar became "the social Mecca for people from Baltimore and Washington wishing to escape the summer heat," wrote Earl Arnett in the Baltimore *Sun*. "With the establishment of the rail line, the mountains became easily accessible to sweltering urbanites."

Tycoons would park their families at PenMar for the summer and then join them on weekends. This contrasted with the indigenous population, much of which was impoverished and took jobs waiting on the rich. "These realities were more hidden then, and seldom were mentioned in the conversations at fashionable parties," Arnett wrote in 1972. "It was a different time, with different notions about wealth and justice."

In a book of remembrances of the park, Leighton Roper of Norfolk, Virginia, wrote that his family would stay from June to October, requiring a mind-boggling number of trunks and cases of empty jars for making jam. (It was Roper's belief that at least part of PenMar's popularity stemmed from the fact that so many Confederate soldiers had noticed the beautiful landscape as they marched south from Gettysburg and made a mental note to one day return under more pleasant circumstances.) As for the potential for boredom over such a long stretch, "The magic of the Blue Ridge was such that I never heard [any complaint] of it. Everyone turned extrovert and made things to do. Like Ireland, the Blue Ridge was not just a place, but a state of mind."

There was also the opportunity to pile all the friends into the car and careen down the mountain to nearby Waynesboro, Pennsylvania. Such a crowd might seem to have the potential for distraction, but it was not the case, Roper wrote. "When there are 12 in the auto and the driver has a two-fisted death grip on the nonhydraulic wheel and you are momentarily expecting a blowout on any of four wheels, you just can't get too involved."

The crowds were enormous for a once-lonely mountain peak. A reunion of Lutherans attracted fifteen thousand, a record that was broken by the seventeen thousand who came to attend a reunion of Odd Fellows. Tourism, at PenMar and beyond, was heavily promoted by train executives, who put out publications such as "Summering on the Western Maryland Railroad." The park's glory days lasted for nearly half a century, which in the lifespan of an amusement park resort is not bad. But of course it couldn't last forever.

Looking back, some say that the bloom began to come off PenMar's rose as early as August 5, 1913. Early that morning, a trucker was hauling a load of vegetables up from the valley when he saw fingers of flame from beneath the porch of the grand Blue Ridge Hotel. A fire had begun in the hotel's

elevator shaft and quickly spread through the pine building. The nearest fire department was miles away. Down below, Leon Werdebaugh got early word of the brewing disaster, mounted his horse and raced to the scene. "We tried to control the fire, but there was no water and few tools and we had no chance," he recalled later. An employee was said to have fired a warning shot from his pistol, and bellhops and servants got everyone out with few injuries—including an elderly woman who had to be carried out in a chair and an infant that was reportedly chucked from a third-story window into the arms of an awaiting hero.

Hoping to help, Werdebaugh rushed into the lobby, but he knew the building's fate was sealed when a desk clerk simply said, "If there's anything in here you want, you better take it." Werdebaugh grabbed what was to become the most famous photo of the hotel from the wall, its edges already black from smoke.

Then there was nothing for the guests to do but stand on the lawn and watch it burn to the sound of liquor bottles exploding when fire reached the hotel bar.

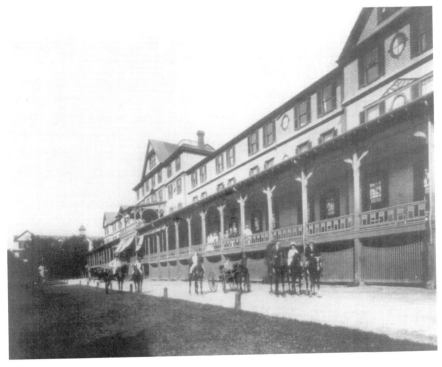

The grand Blue Ridge Hotel, which was the crown jewel of PenMar hotels until it burned down in 1913. *Courtesy* Maryland Cracker Barrel.

Life at PenMar went on after that, but the hotel, although profitable, was never rebuilt, and everyone knew that something special had been lost. By the late '20s, the automobile was siphoning away large chunks of the railroad's business, and free to roam, the public sought other options. Air conditioning was also starting to take hold, and the need to escape the heat was no longer such an issue.

"Pen Mar and the Victorian boarding house could not compete with the automobile and the swimming suit or interest a restless generation that was searching for something new and different," wrote Ward.

In 1930, Western Maryland put PenMar in the hands of a private company, which ran the park for another ten years before World War II put an end to the festivities once and for all. In 1943, work crews came and bulldozed the park—everything—in a matter of hours. PenMar "disappeared from the mountainside almost overnight," wrote the *Waynesboro* (Pennsylvania) *Record Herald*. "A few remains of razed buildings are scattered about here and there on the cleared site that was once PenMar Park and that is all."

The local community was stunned. An influx of military personnel at nearby Fort Ritchie kept the hotels and boardinghouses in business for a time, but the thought that PenMar could be there one day and gone the next was a blow. There were obvious parallels to the Grinch and Whoville, although no one seems to have made the connection at the time.

Even with the nearby military base, the hotels and boardinghouses couldn't last. More fires claimed more hotels. (The Monterey Inn had burned in 1942, and the grand old Buena Vista would burn in 1967.)

A few vestiges of the park were salvaged, including the carrousel with its hand-carved ponies, which of all things was transported in 1945 to the Greatlander Resort in a town nobody had heard of until the 2008 presidential election: Wasilla, Alaska.

In the valley, though, local residents refused to let the idea of PenMar die. Activist Earl Mentzer took the lead and enlisted the support of people and politicians to restore the beautiful spot to parkland. The State of Maryland bought in for a while but then abandoned the idea in favor of a state park called Greenbrier, on the South Mountain ridge several miles to the south of PenMar.

Thwarted by the state, the group turned to Washington County government, and here it succeeded. While still pale in comparison to the "Coney Island of the Blue Ridge," the park is today a splendid, wooded setting with picnic pavilions, an observation platform and a sheltered dance floor, where on weekends big band music still plays and people dance away the afternoons, much as they did a century ago.

THE ARMY CHANNELS
ITS INNER INTELLIGENCE

P enMar was fun and games, but just down the road, South Mountain had a more serious side. Camp Ritchie, later known as Fort Ritchie, is more than six hundred acres of stunning natural beauty, with a small lake nestled amid the ridges of the Catoctin Mountains near the Maryland-Pennsylvania line. Its story is as strange as the landscape is gorgeous.

The pedigree of the land can be traced back to the latter part of the nineteenth century, when Thaddeus Wastler, the son of a Cascade distiller, got the idea that the cold mountain air would be a good raw material for the production of ice. Out of a basin in the hills he scooped a lake and established one of the most southerly ice companies in the United States. For twenty-two years, the Buena Vista Ice Company filled its eleven icehouses with 330 tons of sawdust-packed blocks each winter, which were shipped by rail to Philadelphia, Washington and points south.

By the time refrigeration was beginning to make an anachronism out of ice companies, the Maryland National Guard was looking for a new training ground. Wanting to avoid the heat and mosquitoes of the Tidewater, the military brass turned its attention to the west and settled on the Buena Vista property. In the summer of 1926, Captain Robert Barrick surveyed the grounds and made an appropriately brusque military report: "Well, here we stood. Challenge. Go ahead. Make a Camp out of this place."

It was a challenge, indeed, the land being predominantly populated with forest and rock. Armed with horses and a steam-powered stone crusher, the ice company was gradually fashioned into a training base. Up went stone bathhouses, kitchens, mess halls, living quarters and a club. And, of course, a shooting range. As a final extravagant and aesthetic touch, in went twenty-five thousand flowers and shrubs, because, well, everything seemed rosy and people were optimistic. This was in the summer of 1929. Needless

Left: Captain Robert Barrick and the Castle at Camp, later Fort Ritchie. *Courtesy* Maryland Cracker Barrel.

Below: Jacob Moore and his son, Frank, on a 1925 Harley Davidson. Both father and son eventually worked at Camp Ritchie and were expert sharpshooters. Frank sometimes had to ride home behind his dad instead of in the sidecar, which would be filled with marksmanship trophies. *Courtesy Frank Moore and the* Maryland Cracker Barrel.

to say, that was about the last flourish that Camp Ritchie saw for the next decade.

By 1940, war clouds were darkening the horizon and General George Marshall was concerned about the state of military intelligence—as in we didn't have any. A once-classified military document from 1945 stated: "The state of intelligence training prior to our entry into the war was generally recognized by most observers as leaving much to be desired. The existing facilities for intelligence training were clearly insufficient to meet the demands which would be made upon our armed services in the field of battle."

The United States had few intelligence instructors, materials or equipment. Those soldiers who did study intelligence were never used in their area of expertise, and since trainees were scattered throughout the country, there was no way to get any kind of a handle on those who had the most talent. America needed a unified intelligence-training base where the best instructors and resources could be pooled in one place. But where?

Camp Ritchie, named for former Maryland governor Albert Ritchie, had two distinct assets. One was its proximity to Washington and military headquarters, and another was the mountain terrain that could be used to replicate enemy territory.

"The physical features of the camp and surrounding terrain presented near ideal conditions under which personnel might be trained. Field problems and maneuvers could be planned and simulated under conditions that admirably suited the curriculum of the training program," a military document stated. In June 1942, the federal government took control of Camp Ritchie.

The nearby community of Cascade noticed an immediate difference. "The moment that the Military Intelligence Training Center took charge, Camp Ritchie said goodbye to the headlines," a base history states. "An air of secrecy cloaked not only all activities at the camp, but all personnel sent there as well."

Students were secreted into the base individually or in small groups and sworn to tell not even their wives what they were up to. Of course, such an elite group needed more desirable facilities. The camp went from operating only in summer to year-round. Eleven miles of road and 1,800 feet of rail were built—along with a chapel offering Protestant, Catholic and Jewish services; a theatre; soda fountain; tap room; tailor shop; dance hall; music room; library; commissary; tennis courts; and bowling alleys. (Before the fort closed for good, it would have its own fire department and golf course.)

From a handful of guardsmen the base now supported 3,380, with a capacity of 6,000.

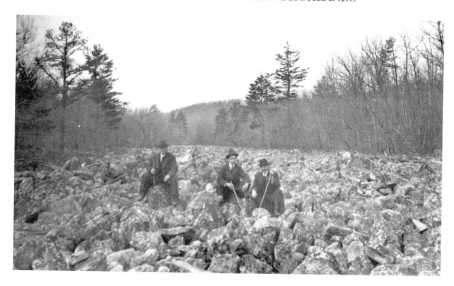

Rocks on the mountain were plentiful for the construction of Camp Ritchie buildings. This formation was known as Devils Race Course. The rocks were eventually crushed and used as a base for a new, straighter version of the Sunshine Trail highway. *Courtesy David Cline and Maryland Cracker Barrel.*

What would have astounded the local community the most, however, would have been the virtual movie sets that were built according to exacting specifications that mirrored enemy fortifications. Mock-ups of German command posts and village houses gave spies a feel for what it would be like behind enemy lines. Military actors dressed in authentic German uniforms so students could recognize the power structure of enemy officers.

One priceless photograph shows an enactment of a German rally (code name: "Der Fuhrer"), featuring an Adolph Hitler stand-in (right hand in the air, heil-style) complete in his dress uniform and stubby moustache. The success of this project is in doubt, since those seated at the rally appear to be doubled over in laughter.

No effort to exude realism was spared. Full-sized German tank models rolled atop army Jeeps, like floats in a parade.

Soldiers were dropped into the mountains in the middle of the night with only a German map to help them find their way out. Lectures teaching German prisoner-of-war interrogation tactics were delivered in German. A cutaway, private "German" residence was used to teach how to apprehend a civilian spy. Graduates (there were ten thousand in all) also learned the ins and outs of German signal equipment, aerial photograph interpretation and translation skills.

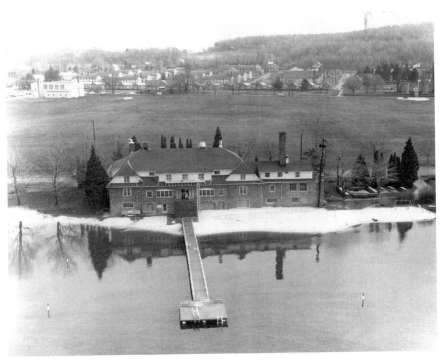

Lakeside Hall, a club at Ritchie, which was first a National Guard outfit and later taken over by the U.S. Army as an intelligence training school during World War II. *Courtesy Maryland Cracker Barrel.*

After the war, the fort reverted briefly to the state but soon returned to federal control as a support center for Site R—which in terms of secrecy made Fort Ritchie during the war look like a PR firm. Site R, just across the state line in Pennsylvania, was carved out of a mass of solid stone known as Raven Rock. The complex is also known as the "Underground Pentagon" and was built along the lines of a self-contained city beneath the mountain. Mark Lewis, in an account given to the *Maryland Cracker Barrel* magazine, said that construction was an amazing and highly secretive feat. Above, below, left and right, it was all solid rock. Armed guards watched the workers—even when they went to the bathroom.

The impetus behind the project, completed in 1953, was the successful testing of a nuclear bomb by the Russians. For decades, all manner of rumors washed through the valley about "what was going on up on the mountain." With the end of the Cold War, secrecy melted away leak by leak, and today its main point of pop culture interest is that it served as Vice President Dick Cheney's "undisclosed location" after 9/11.

Lewis, for his part, went on to work on the presidential retreat Camp David, located several miles to the southeast in the Catoctin. The finishing touch was a helipad for arriving dignitaries, the first of whom was Nikita Khrushchev.

The Soviet premier was due in a matter of hours, and there was a problem—because of damp weather, the concrete wouldn't harden. The thought of the shoe-banging man who said he would bury us being himself buried in wet cement had "international incident" written all over it. Happily, the crew was able to procure some heaters to cure the concrete, which was sufficiently solid an hour before Khrushchev's arrival.

As for Fort Ritchie, it closed in 1998, the victim of the federal base closure act. After a decade of failed attempts to find a new use for the mountain jewel, it was purchased by a real estate investment trust, which has plans for an office complex for businesses and government agencies looking for a less stressful, more rural atmosphere—the PenMar, it would seem, of the commercial world.

Chapter 12

WHAT PROHIBITION?

Before it became a retreat for presidents, the lands around Camp David were home to the illicit production of liquor. Try not to read too much into that. For mystery and intrigue, though, the Camp David accords have nothing on what went on in the Maryland mountains just some eighty years ago.

As a federal revenuer frequently on the road, Hunter Stotler disliked the boarding rooms and greasy spoons that his lengthy career had required him to make use of. So in the summer of 1927, when his junior partner Reginald Walters offered Stotler the comforts of his own home, the older man readily agreed to the hospitality.

The arrangement took an unpleasant turn. Walters's wife, Mary, later stated to police that Stotler had turned up one day with a box of candy under one arm. Upon eating a couple pieces, Mrs. Walters began to feel strange, in the sense that she suddenly found herself attracted to the fifty-two-year-old agent. That led to an affair, although an uneasy one, since Reginald was under the same roof. When asked what would happen if they were discovered, Mrs. Walters surmised that her husband would likely kill one or both of them. Stotler waved off the danger, saying, "Well, I suppose I can shoot as straight as he can."

After a couple of close calls, however, the wife broke down and confessed the affair. Walters, thirty-six, bided his time. He and Stotler maintained cordial relations as they continued their investigation into a nest of moonshiners operating out of Frog Hollow near a small community known as Dargan in southern Washington County.

Then one night they received a tip concerning a still on South Mountain above the town of Boonsboro. After conducting an interview in the village, they hopped in Walters's Dodge and started up the lonely mountain road.

Later that night, Walters sped into Funkstown, shouting for someone to call the police and a physician. The police were useful but the physician was not, Stotler being plenty dead in the passenger seat at the time, killed by one bullet to the head and two to the heart.

For five hours, Walters told the same story—the revenuers had been ambushed by moonshiners, a plausible-enough account since it frequently happened during the days of Prohibition. But the facts were troublesome. How could the bullets, fired through the left side of the car, have hit Stotler but missed Walters? Why did the victim have powder burns on his face, indicating a close shot?

Walters caved. He told of the affair, a point on which he was backed up by his wife. He said the car had engine trouble on the mountain, and he saw his chance. In his confession, Walters said he told his partner, "I'm going to kill you Stot, you broke up my home." Stotler reached for his gun (at his trial, Walters claimed self defense), but he wasn't fast enough. After shooting Stotler, Walters said that the idea came to him to make it look like the work of moonshiners, so he pumped a few more bullets into the car and fired a few round into the air to make it sound—to anyone who might be listening—as if he'd put up a fight.

The papers ate it up. A murder, a revenuer love triangle, drugged candy—that's about as good as it gets in the news business. The police were pretty pleased, too, with their detective work and the fact that they were quickly able to establish the truth.

Except that maybe they didn't.

Longtime friends of Stotler said that he was not the kind of guy to have an affair, and this whole "doped candy" story raised eyebrows. Then there was the inconvenient fact that Mrs. Walters confessed before her husband did.

George Crabbe, superintendent of the Maryland Anti-Saloon League and a longtime friend of Stotler's, smelled a rat. "Poor old Stotler is dead now and his lips are sealed as to what took place on that lonely Boonsboro road," he said. "[But] I feel that the truth will yet be revealed and that it will show that Stotler was lured to his death at the behest of moonshiners who were being harassed."

A private detective and former revenuer in Martinsburg, West Virginia, named Edwin Rinker came forward and stated that Stotler suspected Walters of being tight with the Frog Hollow moonshiners and was preparing to bring his partner up on charges. Robert Shipley of Shepherdstown, West Virginia, said that he'd been in on some of the Frog Hollow raids, and according to the Shepherdstown papers, "The federal men were never sure of Walters' loyalty and were usually on their guard to see that he did not double cross

During Prohibition, a constant cat-and-mouse game was played between moonshiners and revenuers. The revenuers were more likely to pose with the stills. *Courtesy* Maryland Cracker Barrel.

them [because he] had an intimate knowledge of conditions in the mountains of Washington County."

Still, one way or another, police believed that they had their man, so they let the original story stand. Walters was convicted of murder and sentenced to life. He took up art in prison, was paroled in 1942 and died in New Jersey six years later.

So what was it—love triangle or moonshiner assassination?

Moonshiners didn't stay in business by blabbing, so we may never know. Secrecy and slight of hand have been part and parcel of the trade almost from the time the first ear of corn was harvested in the Western Maryland mountains, where hundreds of stills dotted the hillsides.

Stills had been driven into remote mountain ravines well before Prohibition under the twin influences of staggering liquor taxes and a growing temperance movement that was an annoyance if nothing else. But the enterprise did not become stunningly profitable until it was outlawed in 1919.

Several factors contributed to what has to be recognized as a serious industry, not a quaint pastime perpetuated by hillbillies in felt hats and corncob pipes. First, the expertise was already in place. New settlements immediately threw up a sawmill, gristmill and a still, and not necessarily in that order. Particularly after the reduction of the high taxes that led to the Whiskey Rebellion, whiskey flowed like water—or more so, since most people will chose to limit their water consumption. If you traveled ten miles on the National Road, you would likely pass ten taverns. Boys would be appropriated to ladle the fluid from the vats into jugs brought by an unending

line of customers. They would work from dawn until dusk, or until they passed out from the fumes, whichever came first.

Children always played an integral part. In the early part of the last century, one moonshiner operated a still out of his home at Antietam Furnace. Since he routinely got too liquored up to make change, he would drive along the delivery route (driving while intoxicated in those days being less of a concern than counting money while intoxicated; it's all relative), letting his boy run the jars up to the homes and collecting the cash. Every so often, the revenuers would show up at the house. They would bust up the still, throw the pieces out the window and then haul the man off to the pokey as much to sober him up as to punish. In his absence, his wife would patiently collect all the pieces of the still, put it back together and commence operations. The law never caught on to the fact that she, not he, was the distiller in residence.

The raw materials were also in place. Nearby fields produced fine crops of grain, and the mountain water was so pure that Maryland whiskey was well regarded in just about every big city on the East Coast. Finally, stills in western Frederick and eastern Washington Counties had the advantage of markets, being located within a couple of hours from Washington and Baltimore.

A region along the Potomac River straddling the Washington and Frederick county lines was especially prolific. In her *Tales of Mountain Maryland*, Paula Strain quotes a Knoxville resident who in 1979 told the local paper that "there was more whiskey and more moonshine in a 10-mile radius of here than anywhere else in the United States."

Why? Hard to say, although Lloyd "Pete" Waters of Dargan believes that the number of Irish who worked on the C&O Canal (doing as much fighting as digging, if I understand it right) may have had something to do with it.

There were also cultural intangibles at work. Small communities in the mountains were more or less closed. Every man could grow his own food, fix his own equipment and build his own barn. Wives cooked, made the clothes and tended animals and gardens. There was no reason to visit the outside world and, more importantly, no reason for the outside world to visit them.

Until Prohibition, though, whiskey was not all that profitable, and it was more for consumption by friends and family. Big distillers cornered the wholesale market, and even there margins were slim. Taverns used whiskey as a loss-leader, much as convenience stores today will sell gas at next to no profit, hoping the low prices will draw customers into the store to buy more profitable stuff.

Commercial distilleries were boarded up with the passage of Prohibition (some counties had gone dry even before the national law), and without this

The sprawling Roxbury Distilling Company on the Antietam Creek was one of many in the Maryland mountains. The complex included a massive, eight-story warehouse for aging rye whiskey. Prohibition effectively shut it down. *Courtesy Doug Bast.*

mass production, small operators suddenly found themselves in possession of barrels of liquid gold. Overnight the price shot from two dollars to twenty-two dollars per gallon.

Small operators found it tempting to become big operators and sometimes spared no ingenuity. According to an article in the *Maryland Cracker Barrel* magazine, one Washington County distiller—that for creativity made Da Vinci look like Larry the Cable Guy—built his house over a spring to secure the needed water supply and then put up an adjacent two-car garage. The works were beneath the garage. To access the still, a light switch first had to be flipped. Across the room was a large tool chest and next to it a water hydrant. Lifting and turning the handle of the hydrant just so activated a set of hydraulics that lifted the tool chest and revealed a flight of stairs to the basement.

People only got wise when a load of mash was accidentally allowed to flow out of a sewer pipe into a nearby swamp. Even so, the revenuers who searched the house couldn't find the still. The operator revealed its location only after revenuers threatened to burn down his house.

Blue Blazes was another enterprising still—just a stone's throw from present-day Camp David—boasting twenty five-hundred-gallon vats and sales that would, in today's dollars, exceed $6 million. Needless to say, the authorities saw this as a juicy target.

In the summer of 1929, a Foxville resident by the name of Charles Lewis was a mess. According to Edmund Wehrle, he'd been convicted of shooting a man and theft. He worked at Blue Blazes but was not above tipping off the authorities, presumably if the compensation was right.

Lewis met with Deputy Sheriff Vernon Redmond to pass along his knowledge of the still, and a raid date was set for July 31. Almost from the beginning it was a disaster. A caravan of cars drove up the mountain at six in the evening as far as the road allowed, and then a small band of deputies set out on foot up a faint path. It's likely that they hit a trip wire or some other warning device that allowed the moonshiners to take up a defensive position on the rocks.

A volley of gunfire forced the lawmen to fall back—one, Deputy Clyde Hauver, tripped over a root and fell in the process. Again the deputies advanced, but when they did they discovered that Hauver had not tripped but been fatally shot through the head. His fellow deputies rushed him down the mountain as word began to spread. The caretaker of a fishing camp frequented by President Herbert Hoover—who left his car there in the off-season—hopped into the White House car and motored to the scene, which was rapidly filling up with curious onlookers. Driving back down the mountain after the commotion had died down, he was stopped by police, "managing to explain with some difficulty why he was driving the president's car," Wehrle wrote.

The ensuing investigation into Blue Blazes was even more tumultuous than the raid itself. Lewis, accused of double-crossing the deputies, was charged with murder along with two others. Yet the day after the ambush, Lewis was released from custody. Some deputies didn't even see moonshining as that big of a deal and seemed to think it foolish that anyone would provoke moonshiners, who would only attack if threatened.

Then there was the fact that Hauver was shot in the back of the head, indicating a case of friendly fire. At the trial, a witness was produced to testify that Lewis was after Redmond, not Hauver. Another, Osby McAffe, said that Lewis had unsuccessfully tried to arrange a meeting at his home to plot against the deputies. A few days later, McAffe's house burned to the ground.

Finally, people questioned why the raid was conducted while the high sheriff—who scoffed at the setup theory—was out of town.

Whatever the case, Lewis was convicted and sentenced to life, while another moonshiner was sentenced to fifteen years (the rest were charged with the manufacture of spirits).

So that was that, right? Well, no. In 1972, a group from the Youth Conservation Corps went into the mountains to collect folklore. They were told the following: one, that the still owners were from the Carolinas, and local moonshiners tipped off the police because they were upset with the competition; and two, that one of the deputies was involved in a love triangle and the setup was meant to kill him, not Hauver.

Massacres, Moonshine and Mountaineering

Of course, none of this is substantiated, but it's tantalizing to imagine that in Boonsboro you might have had a fake crime of passion story to cover up a moonshiner hit, while at Blue Blazes you might have had a fake moonshiner-hit story designed to cover up a crime of passion. In the end though, it's probably best just to say that the life of a moonshiner was complex and leave it at that.

It's tempting to say that making moonshine is a lost art, except that it's not really lost. Mountain folk can still tick off the ingredients—twelve pounds of corn meal, couple of yeast cakes, eight to ten pounds of sugar—for a nice little batch as easily as if reciting their Social Security numbers. If you have the right connections and they trust you, you can fairly easily be the proud owner of a classic Mason jar filled with sparkling, clear corn whiskey. To see if you like it, you may get a small medicine bottle of the liquid, its potency attested to with an accompanying warning of "You may not want to drink this all at once."

Instead of copper stills tucked into hidden ravines, however, it's more likely that the liquor will have been cooked in someone's house, often in an oversized crock pot.

Some more traditional stills (although they may use propane instead of firewood and plastic jugs instead of stoneware) are likely still around, and every so often one will be busted up by the feds.

It's safe to say, though, that it's far rarer than it was through the first two centuries of Western Maryland inhabitation, when it was hard to find families that didn't distill their own hooch.

Every hill and hollow, just about, bristled with stills, but the aforementioned Frog Hollow offers as good an example of the whiskey-making lifestyle as any, a lifestyle that endures to this day. Waters, a distant relative of Reginald Walters (at some point his branch of the family decided that it liked the sound of Waters better and dropped the *L*), grew up in Dargan, and as late as the 1950s he remembers helping his granddaddy at a still up on the Knob off the old Snuff Road. He also remembers hiding in the basement with his granddaddy—covered with scratches after a headlong sprint through the woods—for several hours until the heat was off.

Dargan was a tight community and a tight-lipped community. "You didn't really go down there unless you lived there," Waters said. "You had to watch for strangers coming down the road and if someone new came to town, everybody knew it."

Homemade brews—beer, wine, whiskey—were a way of life. At butchering time in the late fall, the hogs would be killed and hoisted into a scalding tub so the hair could be scraped. Standing around the scalding tub waiting for

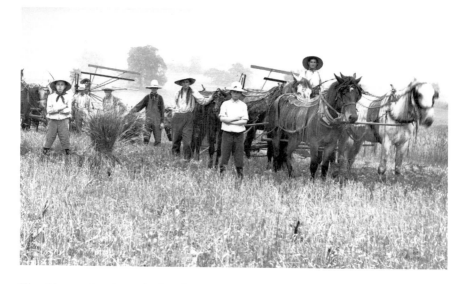

Threshing small grains took a lot of man- and horsepower. The final product may have made it to a dinner table or a local distiller. *Courtesy Doug Bast.*

the hot water to do its work, someone would always produce a Mason jar and pass it around. "It didn't make you warm, but you sure felt warm," Waters said.

His father-in-law was legend for his experiments in liquor. For visitors, he would line up cups with a sample of his latest formulas. Refusing a sample was out of the question. The guest would start with wines—made from grapes, strawberries, dandelions, potatoes or whatever—and work his way up to the corn liquor. At his father-in-law's funeral, Waters said, "I never once saw Leon drunk, but I can't say the same about the people who visited his house."

Although taxation and liquor have reached an uneasy truce of sorts, the issue is not completely dead. The State of Maryland proposed a tax hike on alcoholic beverages in 2009—the first such increase in decades—and, safe to say, the proposal was not greeted with universal praise. On a call-in post to the *Herald-Mail* newspaper, one resident expressed his displeasure as well as his solution: "Raising this booze tax is the last straw. I am not rich. I can't fly to Cancun or take a cruise to the Bahamas like the big shots do. I take all my trips without leaving the farm. I have a still and I ain't afraid to use it."

Chapter 13

THE MOUNTAINS AT PLAY

There is nothing flat about the mountains of Western Maryland. At least there wasn't until the construction of the dam that created Deep Creek Lake, an impressive sheet of water with sixty-five miles of shoreline. When it froze solid, or relatively so, in the winter, a new opportunity presented itself—a slippery, expansive table top that just begged for exploitation by a group of grease monkeys with time and a backlog of *Popular Mechanics* on their hands.

At a garage in downtown Oakland, a group of young men would eagerly anticipate each new issue of the magazine and its plans for crazy contraptions. A corner of the garage was reserved for "tinkering," and some of these plans were put to use. As often as not, the results were never placed into service. This was in 1929, during the barnstorming era, and the boys got the idea that it would be a good idea to build a glider, which they did. But with glider in hand, they were not entirely sure what to do next, so the aircraft went into the rafters of the garage alongside an inventory of similar mechanical blank cartridges.

So having a need for a new project, wandering eyes turned to the frozen lake. "The ice on Deep Creek Lake intrigued all of us," wrote Gerald Iman. "[An] iceboat was a natural project to be planned to take advantage of it." Looking much like a tin-plated soapbox derby entry with skis instead of wheels, the craft was powered by a four-cylinder Chevrolet engine and an airplane propeller. It worked fairly well, except that it had no suspension system, so the ride was rough, and the weight was concentrated to the rear, so steering was problematic. Lacking springs to cushion the ride, the boat went into the rafters next to the glider. There was no time to modify the suspension, because by this time plans for an ice plane had caught the fellows' attention. "Unfortunately, it was one of those things that seemed like a good idea at the time, but didn't work out very well," Iman wrote. At speed, the

tail would rise into the air and catch the wind like a weathervane, sending the plane spinning like a top. It was clear that the device had an imminent appointment with the rafters of the garage.

Deep Creek Lake might be considered the recreational jewel of the Maryland mountains. Other man-made lakes have been created but with lesser degrees of success. At Rocky Gap east of Cumberland a beautiful hotel, convention center and golf course were built by the state alongside a picturesque mountain lake, but the resort has been dogged by financial problems from the beginning and now has been mentioned as a possible location for newly legalized slot machines to right the ship.

Recreation was not on the minds of the men who envisioned Deep Creek Lake. The first scheme for a dam on Deep Creek was hatched in the 1800s. The resulting lake would have been used to water the C&O Canal were it built over the mountains west of Cumberland, which it never was. The idea was revisited for another purpose in 1908 for a different use: electricity. Writing for the 1962 *Glades Star*, Mary Martha Friend Bray reported that the idea was to take advantage of the "wasted water powers of the Youghiogheny River and Deep Creek."

The Reverend John Grant, a Garrett County historian, said that the original plan was for four dams scattered along the watershed, but only Deep Creek saw fruition. Upon completion of the dam, Grant said that it was expected that the four-thousand-acre lake would take two years to fill; but with the mountains' prodigious water supplies, it filled in a matter of months. Curious residents watched the lake's progress as it swallowed up houses, schoolhouses, farms and copious amounts of previously dry land, including the main state road (which had to be rerouted). When the lake was filled, this paved highway ran straight into the lake. One local would amuse himself in winter by thundering down the road onto the ice and then cutting the wheels of his old Model A to send it whirling. Recreation, obviously, was still a work in progress.

Completed in 1925, there was still little idea of what the lake would become, outside of its power production. "There were some nice summer places here and there, a few restaurants and some boating," Grant said. "There was some recreation, but nothing like it is now."

The early sticking point was that the shoreline around the lake lacked, of all things, electricity. One resident, W.B. Love, built a small but working model of a water wheel that used a nearby stream to run a generator. It produced enough electricity to light one bulb.

In 1937, lakeshore residents successfully petitioned for electricity. "That changed everything around the lake," Grant said. The stampede to recreation

was on. Boats popped up like mushrooms, including sailing boats from a thriving yacht club and a curious boat shaped like a swan, with a head that reached fourteen feet above the waterline and had running lights for eyes. Not all comers could be so easily entertained. Perhaps the lake's most famous, or at least smartest, guest was Albert Einstein, who contemplated the unification of physics while sailing the lake's quiet coves.

Well before the lake, of course, mountain resorts on the order of PenMar (*sans* amusement park) to the east had become a popular way to escape the heat of summer. Railroads seeking passengers built many of these destinations, where city folk might come and stay for months—the women and children, at least, as the men would often work during the week and commute to the resort on weekends.

Much of the activity in Garrett County had involved timbering and coal, but after the Civil War, "People started to find out that there was good water up here and good air," Grant said.

There were resorts for the upper crust, including Deer Park. "It was somewhat exclusive," Grant said. "They wouldn't just rent you a room; you had to be somebody." But there were other resorts for the less well-heeled, relatively speaking, as well as resorts for those seeking either vice or the absence of same.

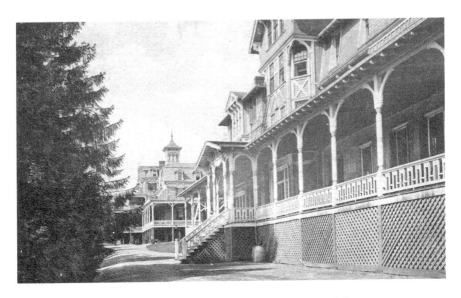

The exclusive Deer Park Hotel at Oakland. "You had to be somebody" to rent a room. *Courtesy Garrett County Historical Society.*

Mountain Lake Park, founded in 1881, led a lively if somewhat tormented existence as a religious-oriented resort patterned after New York's Chautauqua Lake. Founded by four (and maybe a fifth) Wheeling Methodists, Mountain Lake prided itself on having a high moral tone that prohibited cards, gambling, dancing, drinking and other related hanky panky.

They were successful, mainly, but not totally, according to Mary Love. In her book *Once Upon a Mountaintop*, Love writes that as the founders made their plans for morality and virtue, the shadowy fifth partner may have slinked out of the proceedings to purchase nearby land on which he built the Loch Lynn Hotel, which tended to celebrate all the things that would grow hair on the hands of the Mountain Lake crew. The popular saying of the day, Love writes, was on the order of:

If you want to sin, go to Loch Lynn,
But for Jesus' sake, go to Mountain Lake

Naturally, Mountain Lake's history is more relevant, but Loch Lynn's is more interesting. As Mark Twain said, "Heaven for climate, hell for society," and Loch Lynn boasted a membership that was said to include senators, representatives, millionaires and professors. Love quotes from a piece from a local paper in 1895 that gaily portrays Loch Lynn as the "bright and dashing" lass giggling with equal parts amusement and pity at her "sleepy old maiden sister across the way…She is terribly sot in her ways, [while] on our side, everything goes." Its rules were simple: no wearing your religion on your sleeve, no looking down on anyone else and no envy of more well-off neighbors. Loch Lynn credited itself for creating an urgent demand for adjoining lots in both communities, where the pious and sinners built their cottages. Boasting a casino, ballroom and swimming pool, Loch Lynn officially opened in 1885 and took about a decade to go bankrupt. The righteous among us, for whom insolvency is too lenient a punishment, can take comfort in knowing that the hotel burned down in 1918.

Mountain Lake, meanwhile, was making out better. Technically, there was originally no lake at Mountain Lake, a detail that could hardly be left to stand, so with the help of the railroad a stream was dammed, and the resulting impoundment was popular for boating and swimming—although some felt the excessively muddy bottom to be a bit disgusting. In the winter, ice was cut from the lake and stored in sawdust for summer use by vacationers and railroad dining cars.

The summers were filled with programs that included religious services, concerts, civic meetings, fairs, folk festivals and political speeches—including

Massacres, Moonshine and Mountaineering

The Mount Lake Hotel at the religious Mountain Lake Park. Despite its reputation for clean living, it was whispered that some hostelries at the park used this as cover for running moonshine or engaging in other less-than-wholesome pursuits. *Courtesy Garrett County Historical Society.*

one by President Howard Taft, a man of ample carriage, who famously failed to fit in a car provided for a tour of the grounds. A bigger car was called for. Still no luck—until one of the seats was hastily removed.

On a typical day, people streamed from their hotels, cottages and boardinghouses to enjoy a full slate of summer sports and nature walks. A massive amphitheatre that "looked like a huge umbrella" and could seat five thousand people went up in 1899, supported by a complex truss system that precluded the need for interior posts. It was one of the resort's most popular assets and no small source of pride.

Mountain Lake was indeed in better financial shape than the Loch Lynn Hotel, but not by much. Love says that its finances existed in a "never-never land" that was slow to acknowledge potential trouble. Bankruptcy was always a threat. The founders were men much better at communing with the Lord than communing with their accountants, it seems. Likewise, through the decades, peeling paint and missing shingles were often treated as if they simply didn't exist. It was left to improvement societies to plant shrubs and perform general upkeep of the public buildings.

As can be guessed, people were coming to the mountains for fun, and that didn't always jibe with the resort's strict code of conduct. At the turn of the century, the railroad was starting to lose interest and curtailed its financial contributions. Mountain Lake was offered for sale, and it was taken over by a couple of religious-oriented organizations with less than satisfactory results.

During the Depression, many homeowners sold their cottages or tried to. Others sold their primary residences and tried to make do year-round, shivering in houses that were not intended for winter use. By World War II, for the first time ever, there was no summer program. The beloved amphitheatre was pulled down in 1946, a move that is a sore spot to this day.

The community of Mountain Lake lived on even if the pillars of the park did not. And the mountains lived on as popular as ever, even as society and culture were changing around them. Following the Industrial Revolution and new technical wonders of the early 1900s, the mountains offered a way to escape society's maddening modernization, at least according to one fellow who, while camping at Muddy Creek Falls in 1921, said, "I like to get out in the woods and live close to nature. Every man does. It is in his blood. It is his feeble protest against civilization." The man who spoke those words was Thomas Edison.

In 1921, the great inventors and industrialists Edison, Henry Ford and Harvey Firestone embarked on a celebrated camping trip through the mountains of Western Maryland, staying for several days on Licking Creek in Washington County and at the Swallow Falls on Muddy Creek in Garrett County. President Warren Harding joined them at Licking Creek. They enjoyed each others' company, and for a decade they would take a road trip into the backwoods each summer.

Calling themselves "vagabonds," the camping party arrived at its destinations not by the customary railroad but by motorcar. The event was widely publicized and photographed. No doubt they enjoyed the scenery. Nor did they seem to mind the attention.

State Forester Francis Champ Zumbrun wrote for the Maryland Department of Natural Resources:

The publicity that followed these celebrated men on their summer adventures helped to introduce to the general public the pleasure of motorized recreational touring, outdoor recreation and camping. Historians

Thomas Edison catches a nap near Hancock on a camping trip in Western Maryland that also included Henry Ford and Harvey Firestone. *Courtesy Norm Brauer and* Maryland Cracker Barrel.

have noted that these camping trips were "the first notable linking of the automobile and outdoor recreation."

The loud sounds of the motor caravan breaking the quiet of the rural countryside would have certainly drawn the attention of anyone within hearing distance. An Allegany County citizen standing at the right place at the right time along the National Road on the afternoon of July 27, 1921, would have certainly noticed the long caravan of vehicles passing through the area.

What better way to "escape society's maddening modernization" than with a parade of noisy machines and a gaggle of the flashbulb-popping press? Ford was known to personally fix a person's ailing Model T along the way and make contacts for dealerships. This isn't to say they did not enjoy nature (Edison took great pleasure planning these trips to the backcountry), but if the shift these trips created in society was purely a happy byproduct, the sellers of cars and tires could not have been displeased with the results.

Americans began to discover America by automobile.

Armed with motorcars, we became a nation of tourists. Travelers had the flexibility to flit from attraction to attraction at their whim and were no longer tied to the steel ribbons of the railroad. That was bad news not only for the railroads, but also for the likes of PenMar and Mountain Lake, because it deviated from the standard custom of spending the summer in one location.

It was good news for the Old National Pike, which was awoken from its slumber by the chatter of touring cars. Grand hotels were strategically built on the mountaintops, including the Town Hill Hotel that survives to this day as a bed-and-breakfast on a mountaintop that has been called "the beauty spot of Maryland." Travelers seemed stunned that such wild scenery still existed. Gushed one report, "It is a practically uninhabited section that is wild and beautiful beyond anticipation. It seems quite safe to estimate that there may be more bridges than people."

That would change, of course, but even today the stretch of the Old National Pike through Green Ridge State Forest is considered by some to be the last remaining pristine section of the route between Baltimore and Illinois.

With the construction of the interstates, however, the Old National Pike again took a back seat as travelers chose speed over scenery. Unless, of course, they were to leave their cars behind altogether, which they were increasingly doing. Travel had gone from human power to stagecoach to rail to automobile. Today, it has come full circle as hiking, bicycling, kayaking and skiing are among the more popular pursuits.

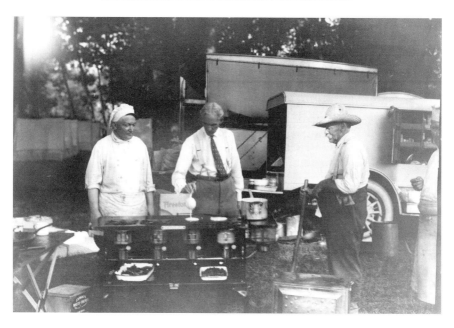

Henry Ford pours pancake batter during a camping trip featuring three industrial captains. The main goal was to get away from it all, but if it popularized automobile tourism at the same time, Ford could not help it. *Courtesy Norm Brauer and* Maryland Cracker Barrel.

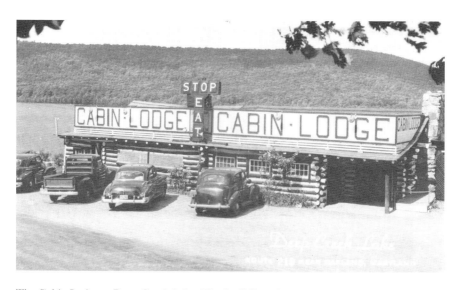

The Cabin Lodge at Deep Creek Lake. The flexibility of automobile travel put grand mountain resorts, where people would stay in one place for the summer, out of business. *Courtesy Garrett County Historical Society.*

Massacres, Moonshine and Mountaineering

By the 1900s in the Northeast, hiking clubs and "Fresh Air Clubs" were beginning to sprout up, despite the fact that many people viewed those who would walk for the fun of walking as one pancake short of a stack.

The Appalachian Mountain Club was largely responsible for changing these perceptions, as it stressed recreation, a break from urban living and nature study. The club was also inclusive—many earlier hiking clubs had been dominated by men. Along with other regional clubs, the AMC helped to build the Appalachian Trail in the '30s, which runs for forty-one miles in Western Maryland along the spine of South Mountain.

Other hiking clubs based in Baltimore and Washington, D.C., celebrated Maryland hikes, but perhaps the greatest boost—or at least the most public—to Maryland hiking was provided not by hiking clubs but by a Supreme Court justice.

The decaying C&O Canal had been abandoned (it had since been purchased by the federal government) for about twenty-five years when fertile minds began to mull the options for the Grand Old Ditch. The predominant thought was that it could be turned into a parkway along the Potomac. The interstates had not been built at the time, and U.S. 40, the Old National Pike, was a twisting, switchbacked inconvenience. The parkway proposal was popular; it would include scenic interchanges and picnic and camping areas, and parts of the canal would be re-watered for fishing and boating.

As the plans gained momentum, however, some in the Potomac Appalachian Trail Club weren't so sure. They began leading hikes on the old towpath, which had become an overgrown home to wildlife and offered quiet, beautiful views of the river and woods.

Someone at the club had the ear of Supreme Court justice and naturalist William O. Douglas.

When the *Washington Post* editorialized in favor of the parkway, Douglas issued a challenge—he and the *Post* editor would hike the 185-mile canal, and then the paper could decide whether it was worth spoiling the sanctuary. The *Post* accepted.

Some derided it as a publicity stunt, which it was, but it worked, and the canal became the nation's longest and thinnest national park. Hikers, bikers and horseback riders today travel what was once the sole property of mules tugging at canalboats.

The industry turned recreation paradigm did not end with the canal. The old Western Maryland Railroad, which once ran tooth by jowl with the canal, has fallen—or been elevated—to outdoor types as well. Passenger and then freight service on the railroad waned through the middle of the 1900s. By 1987, the line had been abandoned, and the State of Maryland paved the

old roadbed with a twenty-two-mile rail trail open to bikers, joggers, in-line skaters and cross-country skiers. It runs from Fort Frederick to a spot near Woodmont, where canalboats would be parked for the winter. Along the way, it passes the ruins of an old brick plant, rolls through abandoned orchards and is virtually an outdoor museum of the old railroad days, explained by a number of historical markers. Those who want the authentic rail experience can board an occasional steam engine–powered excursion, which winds out of Cumberland through the Narrows and up to Frostburg, courtesy of the Western Maryland Scenic Railroad.

Bikers, meanwhile, can expand their trip by cycling the Great Allegheny Passage, called the "crown jewel of Mid-Atlantic rail trails." Completed in 2006, it follows 318 miles of towpath and abandoned rail bed, essentially connecting Washington, D.C., to Pittsburgh.

The memorable route includes passage through the 3,300-foot Big Savage tunnel and is a quick study in the changes that have come to the Maryland mountains in the last fifty years. Routes over which once passed thousands of tons of coal now feel the light feet of joggers and bicycle tires. Wild rivers that were once seen as "wasted energy" now propel rafters, kayakers and canoeists. (The 1989 World Whitewater Championships were held on the Savage River.) Skiers now breeze down slopes that once confounded roadway engineers. Forests once cut for lumber and fuel have regrown and are now enjoyed by hikers. Power generation is now an afterthought on waters that now attract boaters and fishermen. Ruins where men once sweated and toiled for a meager wage have become historic curiosities for tourists.

The mountains of Maryland have the feeling of rebirth, even though they have yet to be truly "discovered." They have a loyal following but have not attracted the masses that flock to more familiar eastern ranges. Writing for *Backpacker Magazine*, Joe Savage reported:

> *Big Savage Mountain is a part of the Appalachian Mountain Range that is frequently overlooked. It's almost hidden in the north-west Maryland Panhandle, but is not hard to reach for those who know of it...Perhaps the visions of hardship that the name suggests keep people away—and its rugged terrain well-deserves the name—but all the better for those seeking solitary refuge.*

Indeed, the mountains have known hardships, borne by the people who worked the mines, fought bears and panthers, hid from revenuers and, most importantly, laid the groundwork for populating the interior of a young nation. The Western Maryland mountains have done their work; they've earned the right, along with everyone else, to relax.

ABOUT THE AUTHOR

Tim Rowland, forty-nine, is a humor columnist for the *Herald-Mail* newspaper in Hagerstown, Maryland. He has written several books—most recently *High Peaks: A History of Hiking the Adirondacks from Noah to Neoprene* (The History Press, 2008). An avid outdoorsman, he has ridden a bicycle across the United States, journeyed on Bolivia's "Highway of Death" and hiked the mountains of Nepal, Norway, Alaska and the Italian Alps. He has written extensively of these adventures, offering up "constructive criticism" of such things as third-world guesthouses, Thai drugstores and Peruvian taxi drivers along the way. A fan of sustainable, local agriculture, he lives with his wife, Beth, on Little Farm by the Creek near Boonsboro, Maryland, where the couple raises goats, cattle, alpacas and chickens with the sincere hope of one day being able to hook up an electric fence without getting fried.

Visit us at
www.historypress.net